IMAGES
of America

SUSSEX COUNTY

IMAGES
of America

SUSSEX COUNTY

Wayne T. McCabe

ARCADIA

First published 2003
Reprinted 2004

Published by Arcadia Publishing,
an imprint of Tempus Publishing Inc.
Portsmouth NH, Charleston SC, Chicago,
San Francisco

Printed in Great Britain

Library of Congress Catalog Card Number: 2003107449

For all general information, contact Arcadia Publishing:
Telephone 843-853-2070
Fax 843-853-0044
E-mail sales@arcadiapublishing.com
For customer service and orders:
Toll-free 1-888-313-2665

Visit us on the Internet at www.arcadiapublishing.com

CONTENTS

Introduction 7

1. Native Americans 11

2. Early Sussex County 15

3. Industrialization and Agricultural Development 29

4. Suburban Development 61

5. The 150th Anniversary 97

6. Modern Sussex County 103

7. Sussex County Lost 109

ACKNOWLEDGMENTS

SUSSEX COUNTY BOARD OF
CHOSEN FREEHOLDERS

Freeholder Director Harold J. Wirths
Deputy Freeholder Director JoAnn D'Angeli
Freeholder Gary R. Chiusano
Freeholder Glen Vetrano
Freeholder Susan M. Zellman
County Administrator Gregory C. Fehrenbach
Deputy County Administrator John N. Eskilson
Clerk of the Board Elaine A. Morgan

250TH ANNIVERSARY CELEBRATION
STEERING COMMITTEE

Chairman Wayne T. McCabe
Joseph Buiso
Lois de Vries
Dr. Bradley M. Gottfried
Beverly Post Ketterer
Secretary Diane Eakman

The history of any area can only be documented through the ongoing and cumulative effort of a number of dedicated individuals—archaeologists, social historians, architectural historians, genealogists, physical anthropologists, newspaper reporters, and even planners. As Kate Gordon once stated, "without the efforts of those who went before us, deliberately or unconsciously, to preserve our heritage, there would be no history." Accordingly, this author would like to thank all of those people who have taken the time and effort to write about the numerous small strands of life that, when woven together, make up the fabric of the history of our county. I also want to express my gratitude to all of those amateur and professional photographers who recorded events and scenes—from the mundane to the catastrophic—over the last 150 years. Without these people, we would not have an understanding of how we got to where we are today.

My special thanks goes to Glenn Wershing, who shared with us his substantial knowledge about the Native Americans who first settled our area. Also, I want to thank Ron Dupont for his sage counsel and assistance in the development of this book. Additionally, my appreciation goes to Kate Gordon, my partner with whom I normally write local history books, for taking on a major editing task. Also, my sincere thanks to Margaret Lake for her help in keeping the photographs in order and making sure my punctuation did not get too far out of hand.

I would also like to thank Sen. Robert Littell for the loan of the photograph used on page 53. A special expression of appreciation is extended to the New Jersey Archaeological Society for permitting the use of the graphics and text relating to Native Americans in Chapter One.

This book was made possible, in part, by a General Operating Support Grant from the New Jersey Historical Commission, a division of cultural affairs in the New Jersey Department of State. These funds were administered by the Sussex County Arts and Heritage Council, a private, nonprofit agency designated by the Sussex County Board of Chosen Freeholders as the official arts and heritage organization for the county.

Special appreciation goes out to my fellow members of the 250th Anniversary Celebration Steering Committee, who spent many long hours in meetings trying to determine the best way to present the public with a photographic history of our county. I also want to thank the Sussex County Board of Chosen Freeholders and their staff for the continuing support and push they put behind this book.

Finally, I also wish to extend a special posthumous thank-you to Jean Shepherd. Excelsior!

INTRODUCTION

On one unheralded day c. 10,000 B.C., the first people arrived in Sussex County: men, women, and children carrying all of their worldly belongings. They were the Stone Age hunters and gatherers that archaeologists call the Paleo-Indians. Their artifacts, although rare, can be found in Sussex County. The Zierdt site in Montague was excavated by archaeologists and provided valuation information on these, the first Sussex County residents.

In the Paleo-Indians' day, the glaciers that had covered Sussex County with up to 9,000 feet of ice were gone, but the climate was still colder, cloudier, and stormier than it is today. In the wake of the Ice Age, the landscape was one of ice-scoured ridges and valleys with rivers and lakes, a tundralike mosaic of forests and grasslands. Mastodons and mammoths roamed the countryside. Caribou, musk-oxen, moose-elk, giant beavers, ground sloths, and other cold-adapted animals were also present and fed on the lush vegetation. However, no evidence of large predatory carnivores such as the dire wolf, saber-toothed cat, or short-faced bear has been found in the area.

The Paleo-Indians coexisted with the Pleistocene animals in this rugged environment. They were not numerous and traveled in small bands. The men carried spears with fluted (Clovis-type) stone points. Their other tools included knives, several types of scrapers, gravers, and drills made of flintlike stone. They also made tools of perishable materials such as wood, bone, fiber, skin, antler, and ivory, and lived in rudimentary skin-covered shelters. The phrase "feast or famine" describes their lifestyle. Infant mortality was undoubtedly high, and life expectancy was short, perhaps 35 to 40 years.

By 8000 B.C., the weather had become warmer. Most of the Pleistocene animals followed the cold north or became extinct. Some of the Paleo-Indian people probably followed the animals northward. Others merged with or were overwhelmed by people of the more developed Archaic cultures coming into the area from the south and west.

Archaeologists call the years between 8000 and 1000 B.C. the Archaic period. Small bands of hunting and gathering people still roamed Sussex County, but their stone tools differed from those of the earlier Paleo-Indians.

After 4000 B.C., mixed forests of oak, hickory, and chestnut replaced earlier forests of hemlock and oak. This provided more mast (acorns and other nuts) and an increased understory for browsing animals such as deer, elk, turkey, and other game. Populations of both people and animals increased during this period.

The Archaic people's main hunting implement was the spear. Many types of spearheads were used over the years, reflecting different hunting requirements, influences from other cultures, and new people moving into the area. The major influences are from the south (Piedmont) and the north (Laurentian).

To improve the force and accuracy of their spears, Archaic hunters propelled the weapons with *atlantls* (Aztec for "spear throwers"), hooked, leverlike devices. *Atlantl* counterweights, or "banner stones," were made of various types of stone and in several shapes and sizes. Some, especially the delicate winged type, were very elaborate and may reflect the belief in a form of magic to help guide the spear to its target.

The Archaic people also used bolas for hunting. These consisted of three or four grooved stones connected by lengths of cordage. When thrown at a prey animal or bird, the cords would entangle the victim, thus immobilizing it. The Gauchos of Argentina still use bolas.

The Archaic Indians learned how to work stone by pecking and grinding, and developed new types of implements. Grooved axes, celts, gouges, and adzes for heavy woodworking (dugout canoes, tree felling, lodge construction) were now manufactured. Also, milling implements were made to process seeds, nuts, and berries (pestles, mortars, mullers). Smaller items, such as ulus (knives), net sinkers (for fishing), shaft smoothers, bola stones, and sinew stones, were also

produced at this time.

Near the end of the Archaic period (c. 2500 B.C.), soapstone (steatite) pots and pottery cooking vessels were introduced. These items revolutionized Indian cooking and had a positive effect on their diet. Meat, in particular, could be boiled until it was tender and became easier to chew and digest. However, the Archaic Indians still did not have agriculture, and their only domesticated animal was the dog.

Near the end of the period, two new groups of people with distinct cultures appeared on the scene: the Meadowood (1200–500 B.C.) and the Orient (1200–600 B.C.) people. The Meadowood people came from northern New York. They were not numerous and are only represented by a few camp sites and burials. They had distinctive side-notched spearpoints, cache blades, pottery, tobacco pipes, birdstones, gorgets, and pendants. The origins of the Orient people are obscure. They lived in small semi-sedentary groups and used distinctive fishtail spearpoints. They also had soapstone pots, pottery, pendants, and gorgets. They netted fish and dried them on platforms over heated rocks.

Archaic sites and artifacts have been found all over Sussex County. A few of the important locations are the Shotwell farm in Green Township, Black Creek in Vernon, and Nomanock and Rocklein in Montague.

The Woodland period, which lasted from 1000 B.C. to A.D. 1600, was one of change and development, with growing influences from outside cultures. The Orient and Meadowood cultures continued from the Archaic period to 600 and 500 B.C., respectively. Another culture, the Middlesex Adena (1000–300 B.C.) appeared on the scene and added an air of mystery. This exotic culture is unique and shares a number of traits derived from, or influenced by, the Adena people of Ohio.

An Adena site was discovered at the Rosenkrans Farm in Walpack. It was a mortuary complex containing 16 identified graves with grave goods, each in a separate grave pit. The individuals had died and had been cremated or buried somewhere else before being reburied at the site.

The skull of one adult man at Rosenkrans is particularly interesting. The front teeth in his upper jaw had deliberately been removed (probably bettered away) to form a rectangular opening. Skulls found in three Adena mounds in Kentucky and Ohio had similar dental extractions and were identified as belonging to "wolf shamans." The matching portions of the upper jaw of a wolf were carved and shaped to fit into the slot made by the extracted teeth in the shaman's mouth. The shaman, wearing a wolf mask and hide and manipulating the inserted wolf maxilla with his tongue and making strange sounds, would indeed have been an intimidating "medicine man."

The grave goods placed in the Rosenkrans Farm reburials included copper-bead necklaces and bracelets, flint and chert spearpoints, gorgets, pendants, boatstones, tubular blocked-end tobacco pipes, drills, shell beads, and celts. They provide evidence for the far-flung trade routes that must have existed in early Woodland times. The copper was from the Great Lakes; the chert and flint, from Ohio, Tennessee, Indiana, Dakotas, and Labrador. There were also items and materials from Arkansas, Ohio, New York, Pennsylvania, and Delaware, as well as shells from the Atlantic coast (and perhaps the Gulf of Mexico coast).

By A.D. 500, the bow and arrow replaced the spear, greatly improving the efficiency of the Indian hunter. Arrows were tipped with triangular points. The earlier points were larger (Levanna), but as time passed smaller points (Madison) were favored. At Dark Moon in Green Township, archaeologists excavated a small village that was the site of an arrowhead factory. The Indians quarried local black chert and produced arrowheads by the thousands. Also at this time, the celt (an ungrooved ax) replaced the grooved ax. The celt was hafted into a socketed handle and was an extremely efficient woodcutting instrument.

Horticulture was introduced during the Woodland period. By A.D. 1000, the Indians had a full complement of crops, including tobacco, maize (corn), beans, and squash. The only domesticated animal was still the dog. Deer were the most important game animals, followed by elk, bear, and turkeys. Fishing was extremely important along the Delaware River and its

tributaries. Fish were netted, speared, and trapped. Fish such as shad, alewives, sturgeon, and eels were a staple of the Indian diet.

Better-quality ceramic cooking pots were being made in new shapes and with distinctive decorative designs. One type of pottery was known as Owasco Corded ware (A.D. 1500). These pots had round flared collars with cord marked designs. Pots known as Munsee Incised pots had beautifully incised castellated collars. Woodland period pots had rounded bases and could not stand upright. They stood between stones in the hearth for support or were fixed with a collar and suspended over the fire.

The Woodland period Indians made dugout canoes from the trunks of tulip, oak, or chestnut trees hollowed out with fire and adzes. Some of the larger canoes held up to 20 people. Birch-bark canoes were not made in this area because canoe birch or paper birch trees do not grow here. Some small canoes were made of elm bark.

As time passed, Woodland lodges became larger. Some were 20 to 60 feet long. They were rectangular with rounded ends and a door in the middle of one side. They were constructed of saplings driven into the earth and lashed together to form a domed roof. This framework was then covered with sheets of bark. The lodges had no windows; fireplaces were in the center isle, and smoke holes in the roof acted as vents.

The Woodland Indians had a well-developed culture with a language, religion, and social order. They were evidently peaceful and had no fortifications. They traded with neighbors and had a system of trails. Unfortunately, their fairly tranquil existence soon came to an end with the advent of European colonists and traders. Disaster awaited.

Woodland sites are scattered over the county; a few important ones are Minisink Island in Montague, Dark Moon in Green, and Rosenkrans in Walpack.

The first European colonists and traders found the local Indians peaceful and eager to trade. They called themselves Lenape, which means "common" or "ordinary" people. William Penn described the Lenape as "generally tall, straight, well built and of singular proportion, they tread strong and clever and most walk with a lofty chin." Most early accounts of the Indians were favorable.

The Lenape language was part of the Algonquin language family. In New Jersey, two Lenape dialects were spoken. Those living to the north of the Raritan River and the Delaware Water Gap spoke the Munsee dialect. Those to the south spoke the Unami dialect. Accordingly, Sussex County Indians spoke the Munsee dialect and were of the Minisink Band. The English initially called all of the Lenape Indians "Delaware." Over time, however, the name Delaware stuck to just the Unami speakers. The Munsee and Minisink were usually referred to by their names.

The village of Mennissinke (on Minisink Island, Montague) was well known, and the famous Minisink Trail passed through it. The trail led west to Wyoming (Wilkes-Barre, Pennsylvania) and east to the Navesink River and the Atlantic coast. The Minsi Path from below Philadelphia also passed through Mennissinke on the way to Maghaghekmek (Port Jervis) and Esopus (Kingston) on the Hudson River.

The Indians were eager to trade furs for European items such as blankets, rum, copper kettles, iron axes, firearms, knives, trinkets, iron hoes, and colored cloth. Soon, the Minisink Indians emerged from the "Stone Age" but at a terrible cost. Many became addicted to rum. European diseases, especially smallpox, took a terrible toll on the Indians. It is estimated that between 1609 and 1710, the Indian population declined by more than 90 percent.

In 1677, at Albany, New York, the Covenant Chain was established. It united the English colonies of New York, New Jersey, Massachusetts, Connecticut, Maryland, and Virginia with the Indian tribes within those colonies. It was established as protection against the French and their Indian allies. The Iroquois were given a preeminent position among the Indians within the Covenant Chain.

Soon after this, the Munsee and Delaware were subjugated by the Iroquois and became their tributaries. They were largely dispossessed and forced west into Iroquois-dominated portions of Pennsylvania and Ohio, and the status of "women" was conferred on them. They essentially

had no rights, and their "cousins" the Iroquois spoke for them and advised them in matters of land sales and other transactions.

The French and Indian War (1754–1763) found the Delaware and Munsee siding with the French. The French gave the Delaware and Munsee the black war belt and weapons and told them to get even with the English for their lost lands. Teedyuscung, self-proclaimed king of the Delaware, ravaged northeastern Pennsylvania and raided into New Jersey. The raids into New Jersey were bloody, and the Delaware River was the frontier. The people of New Jersey built a string of forts (fortified houses, some with stockades) along the river from below the Delaware Water Gap to above Port Jervis (from south to north, Fort Reading, Van Camp's Fort, Fort Walpack, Fort John's, Fort Nominack, Fort Shipeconk, Coles Fort, and Fort Gardiner), manned them with frontier guards, and set a bounty on hostile Indians. Many families moved out of Sussex County for safety.

One notable raid was the Swartwout Raid, which penetrated the deepest into New Jersey (15 miles). On May 20, 1756, an Indian raiding party crossed the Delaware River, intent on killing or capturing three Colonial militia officers: Capt. Richard Hunt of Hardwick (now Hunt's Pond, Fredon), Capt. Daniel Harker of Stillwater, and Capt. Anthony Swartwout of Great Pond (now Swartswood Lake). The raiders found that Richard Hunt was not at home, so they captured his younger brother, Thomas, and a black slave named Cuffee and burned the cabin. They then went to Daniel Harker's farm but dared not attack because there were about a dozen men at the house. The next day, they attacked Anthony Swartwout's farm. They killed Swartwout's wife and three of her children. Anthony Swartwout and three more children were in the house. They were forced to surrender and were led away. About a mile from the house, Anthony Swartwout was murdered. One account reads, "They beat him, lacerated him, and forced him to wind out his bowels around a tree by walking around it." The raiders also killed Swartwout's young daughter, who was probably too young to travel fast. The remaining captives were taken across the Delaware River and were detained at Indian villages on the Susquehanna flats.

The raid has a strange aftermath. A man named Benjamin Springer and two others arrived at Coles' Fort (Port Jervis) after escaping captivity from the Indians. Springer said that he had been taken prisoner at the Swartswood farm and that Thomas Hunt had been killed trying to escape. A year after they were captured, the two surviving Swartwout children (Thomas and his sister) were released, and they returned home. They swore that Benjamin Springer, in disguise, was the murderer of the their father. Springer was tried. On the testimony of Thomas Swartwout and contradictions in Springer's story, Springer was found guilty and hanged. However, Thomas Hunt had not been killed. He was held captive for three years and nine months. He had been sold to a French officer as a servant. He swore to his dying day that Benjamin Springer was innocent and was a prisoner like himself.

In October 1758, the Council of Easton (Pennsylvania) successfully ended the Delaware Indian War and their alliance with the French. It also settled the Minisink-Munsee claims "that they were wronged out of a great deal of land." Segughsonyout (alias, Thomas King), an Oneida chief, spoke on behalf of the Minisink and Munsee and requested Governor Bernard of New Jersey to raise his offer of $800 to $1,000 (Spanish currency) to settle the claims. Chief Egohohowen of the Minisink and Chief Aquaywochtu of the Waping accepted the offer. The agreement settled all Indian claims to northern New Jersey, including Sussex County.

The Minisink faded from Sussex County history.

Where are the Munsee Indians now? Their two main communities are located in Ontario, Canada: Munceytown and Moraviantown. They are striving to preserve their heritage and to conduct a revival. Only a few Munsee speakers survive, and they reside in Moraviantown. Munceytown was founded in 1784, and most of the remnant Munsee reside there. A few Munsee also reside on the nearby Six Nations Reserve.

—Glenn Wershing

One

NATIVE AMERICANS

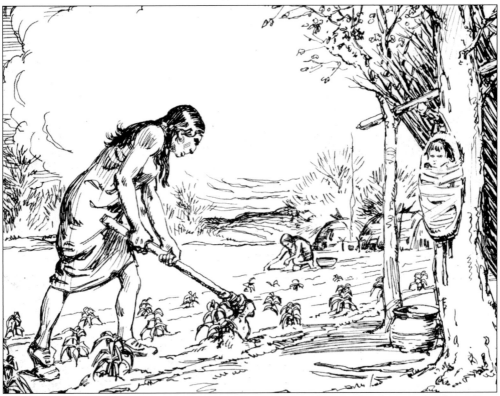

Extensive agriculture was practiced, gardens being placed immediately outside the village compound, as seen in this image. Men cleared the ground, and women cultivated the crops with crooked sticks or crudely chipped stone hoes tied to wooden handles. Corn, squash, and beans were planted in the same field. Sometimes, fish were used as fertilizer. The papoose on a board was hung on a convenient tree while the mother worked.

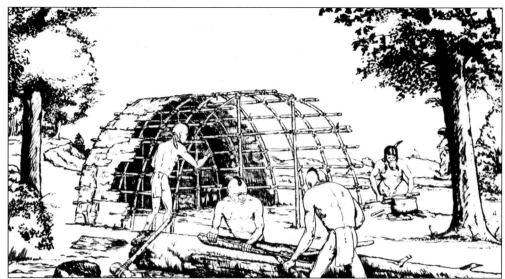

One of the favorite houses was rectangular with an arched roof. Saplings were driven into the ground about two or three feet apart, indicating the size and shape of the house. The slender tops of the saplings were bent and lashed together, forming the vaulted roof. Other saplings were tied crosswise over the upright poles to make the framework more secure. The permanent habitations were shingled with large pieces of bark.

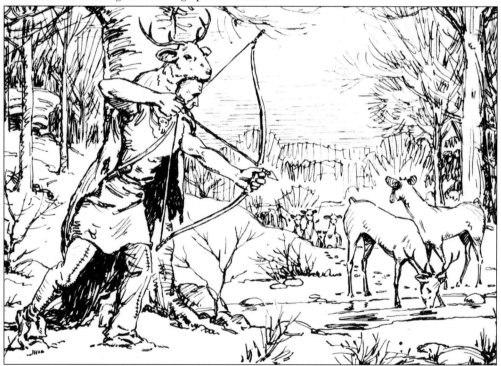

Men hunted alone or in groups during stated seasons. Deer, elk, and bear were the most coveted game, and sometimes the animals were stalked for hours by hunters wearing disguises. The bow and arrow was the favorite weapon. Bows were made of ash or hickory, and arrows were fashioned from reeds tipped with stone, bone, or antler points.

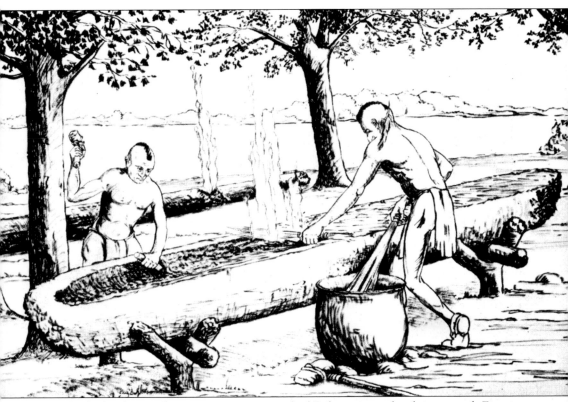

The method of making a dugout canoe was typical of Delaware woodcraft in general. First, a tree was felled by burning a section near the base and removing the charred portion with a stone ax. The interior of the log was hollowed out by placing flaming dried branches or glowing coals upon the surface to be removed. The part that was not to be burned was soaked with water or covered with wet clay or mud. As the wood burned, the charred fragments were scraped away with stone adzes or gouges. When the desired inside space was obtained, the outside was shaped into a pointed bow and stern.

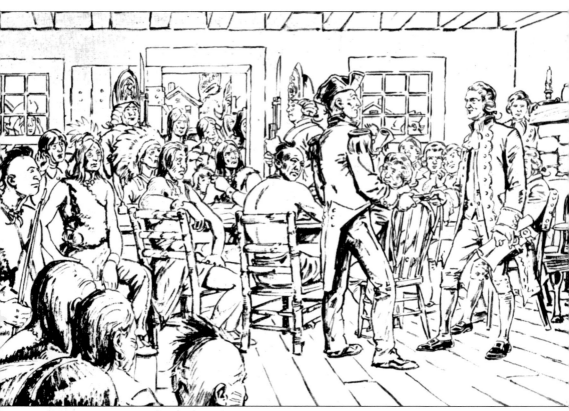

Teedyuscung was chief of the Delaware Indians at the Council of Easton, Pennsylvania. He is shown as he appeared in October 1758. Teedyuscung hated the "whites," but he imitated them at meetings and appeared elaborately garbed in a French military coat and cocked hat. Eventually, peace was reached with the Delaware and Minisink, and their alliance with the French was terminated. The bloody Indian raids into northeast Pennsylvania and Sussex County ended. At this council, Chief Egohohowen of the Minisink and Chief Aquaywochtu of the Waping accepted $1,000 (Spanish currency) from Governor Bernard of New Jersey to settle all Indian claims to northern New Jersey, which included all of present-day Sussex County.

Two
EARLY SUSSEX COUNTY

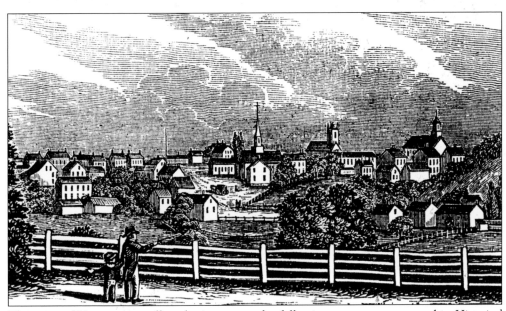

This view of Newton, as well as the images on the following two pages, appeared in *Historical Collections of the State of New Jersey* (1844), by John W. Barber and Henry Howe. Here, Newton is seen from the north, with the steeple of the county courthouse seen in the middle. The spires to the right of the courthouse are churches. Newton was originally formed as New Town Precinct on March 27, 1751. The designation as a precinct was dropped in 1798, when the township was formally incorporated. In 1845, two sections of the township were given over to two new municipalities, Sparta and Lafayette Townships. The year 1853 witnessed yet another portion of the township being annexed to Green Township. Newton Township was abolished on April 11, 1864, when it was divided into Andover and Hampton Townships and the town of Newton.

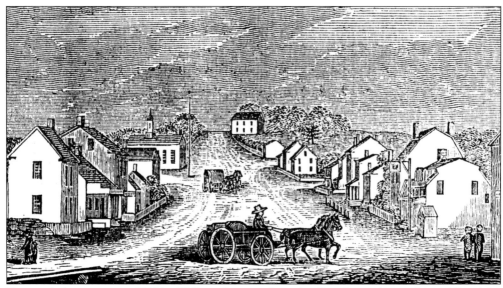

First settled just prior to 1700 by William Beamer, Branchville is located near the middle of the county. The name (originally Brantown) was changed to Branchville c. 1821. During the early 1800s, the village witnessed the beginning of a major expansion with the building of mills and mercantile establishments. Further expansion took place when the Sussex Railroad extended a line into the village in the late 1850s.

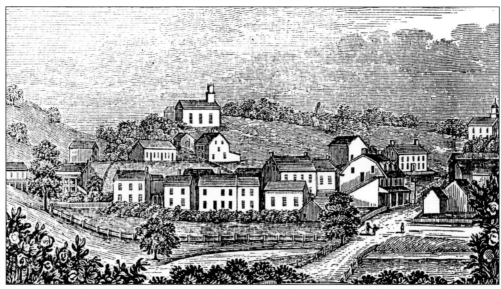

Before Sussex Borough was formally established, the village was simply known as Deckertown, named in honor of the early settler Peter Decker. This is how Deckertown appeared in 1844. The view looks north from the southerly side of Clove Creek. When first formed as a municipality, Deckertown Borough was established on October 14, 1891, by referendum, created from lands in Wantage Township. On March 2, 1902, the town was renamed Sussex Borough.

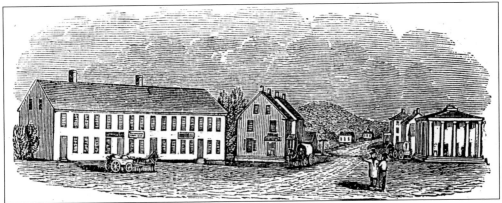

The center of the village of Lafayette is seen in a view looking up Main Street (present-day Route 15). Lafayette Township was created on April 14, 1845. Land for the township not only came from Newton, but Frankford Township as well. The township was named in honor of the Marquis de La Fayette, a French general who served with great distinction with the American forces during the Revolutionary War.

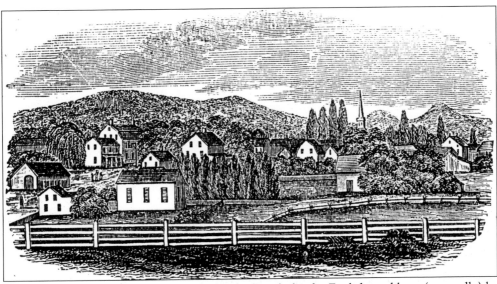

Sparta was first settled in the late 1600s by the Dutch, by the English, and later (reputedly) by the French Huguenots. Developing as an agricultural community, the township was formally established on April 14, 1845, being formed from lands in Byram, Frankford, Hardyston, and Newton Townships. The village of Sparta, seen in this engraving, was one of several hamlets in the township, including Ackerson, Edison, Houses Corner, Monroe, Sussex Mills, and Woodruff's Gap.

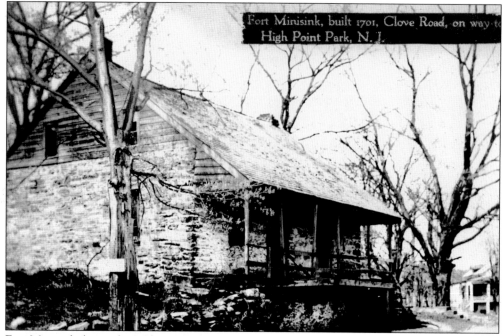

Fort Minisink, built 1701, Clove Road, on way to High Point Park, N. J.

Fort Minisink, located on Clove Road in Wantage Township, was also known as the Titsworth Homestead and later as Locust Grove Farm. The house, built in the early 18th century, was constructed of local fieldstone set in random courses.

Constructed in 1776, the Brick House Hotel was located on River Road in Montague where Route 206 now crosses the Delaware River. This hotel served as a stage stop for those people traveling across the river or down along the Old Mine Road. The hotel was demolished to make way for the realignment of Route 206.

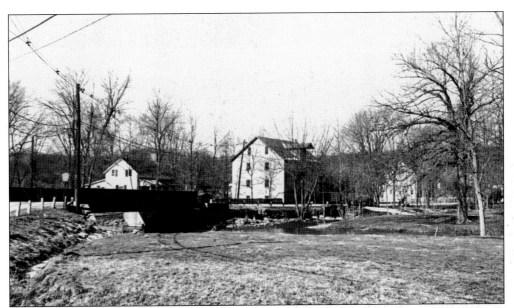

Milling was one of the earliest industries that developed in Sussex County. Native stone, which was readily available, made an excellent building material for such a structure. The numerous rivers, streams, and creeks provided the water power needed to drive the millworks. Seen in this view, looking west from the east bank of the Paulinskill, is a part of the village of Stillwater, with the miller's house (left) and gristmill (center).

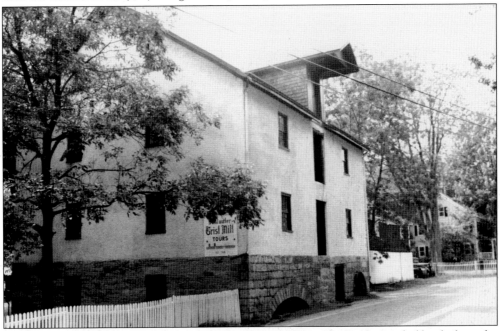

The original Stillwater gristmill was built in 1741 by Casper Shafer about a half-mile from the present mill location. The mill was moved to the present site in 1764 and operated until 1840, when the building was destroyed by fire. The present mill was built in 1844. The mill is run from water diverted from the Paulinskill through a raceway that leads beneath the building and drives the turbine.

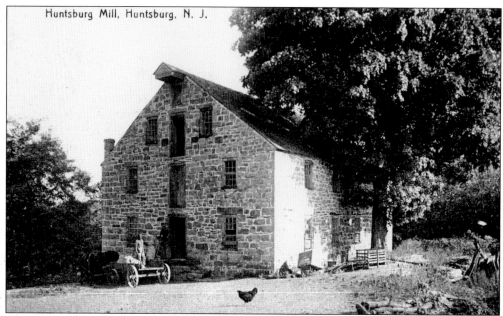

Huntsburg Mill, Huntsburg, N. J.

Another mill that still stands is located in Huntsburg, in Green Township. The stone mill, designed by millwright Simon Fronze of Easton, Pennsylvania, was erected by Thomas Phillips Hunt in 1834–1844. Built alongside another mill, this stone structure first milled clover seed and was later converted to a gristmill. The mill operated from 1844 to 1927.

The Rutan log cabin is a good example of the dwelling that early settlers in Sussex County might have constructed. Built c. 1800 with half-dovetail joinery in the corners, the cabin was located in Frankford Township when it was placed on the National Register of Historic Places. The cabin was moved in the early 1990s to Waterloo Village in Byram Township, where it was restored.

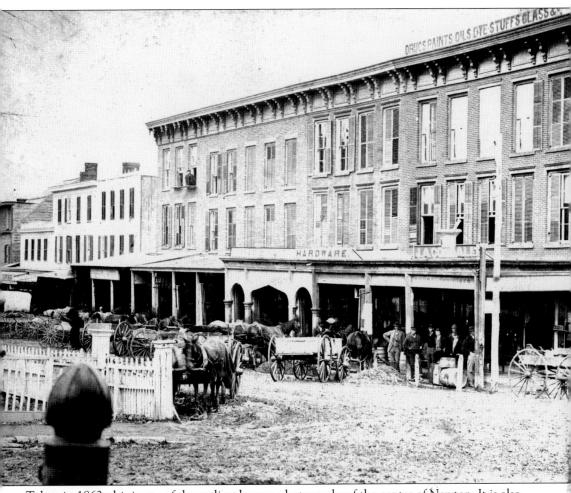

Taken in 1862, this is one of the earliest known photographs of the center of Newton. It is also the earliest known streetscape photograph of any town in the county. Facing the county park (public green), the view shows the north side of Spring Street. The brick buildings, which still stand, were constructed between 1856 and 1860. Unfortunately, the wooden awnings that covered the sidewalks were demolished c. 1900, a casualty of changing fashions in the design of commercial storefronts. The wood picket fence that enclosed the public green stood from 1845 to 1871. The buildings on the far left were demolished in the late 1800s and were replaced with elegant brick commercial buildings. In turn, these buildings were torn down in the early 1970s as part of an urban renewal project.

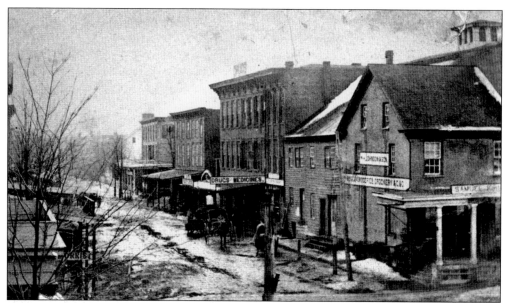

This is one of the earliest views of the corner of Main and Spring Streets. The photograph was probably taken during the winter of 1870–1871, after an early snowstorm and just prior to Samuel Johnson demolishing the structures on the corner to make way for his new brick storehouse (see below). The dilapidated wooden building on Spring Street behind Johnson's storehouse was a rare survivor of the town's 18th-century commercial structures.

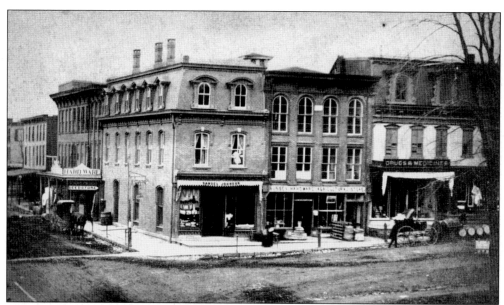

Samuel Johnson completed his new brick storehouse at the corner of Main and Spring Streets in October 1871. The building reflects the Second Empire style, with a mansard roof and elliptical roofed dormers. Johnson was a prosperous dry goods merchant, selling men's clothing, ladies' apparel, fabric, notions, china, carpets, lighting fixtures, and diverse housewares.

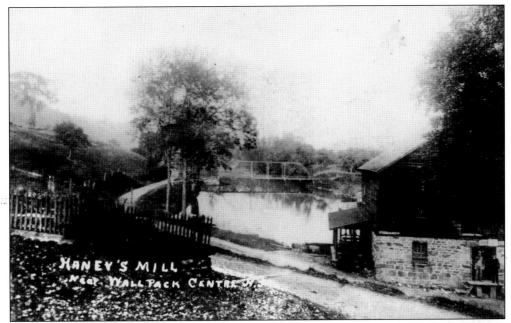

Haney's Mill is a former locale situated in the center of Walpack Township about a mile north of Flatbrookville. By 1860, the area had a gristmill and a sawmill (which were powered by the Flat Brook), a lime kiln, and a few residences (including those of C. Haney, J.W. Fuller, and B.D. Fuller). Jake Haney was the last operator of the mill.

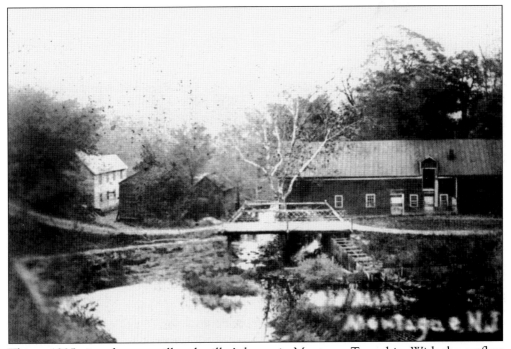

This *c.* 1905 view shows a mill and miller's house in Montague Township. With the outflow from Mashipacong Pond to power the mill, the water is diverted from the stream and through a wooden flume box that passes beneath the right side of the iron bridge.

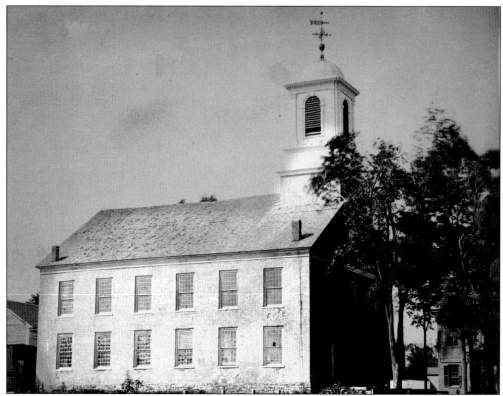

After Newton's Presbyterian congregation was formed in 1786, construction on a small sanctuary on Church Street began. It took nearly 20 years to complete the first church, as funds were extremely tight. By 1827, the congregation had grown and was thriving and debt-free. In 1828, the congregation bought a piece of land at the corner of High and Church Streets and began to erect this impressive stone church facing onto High Street.

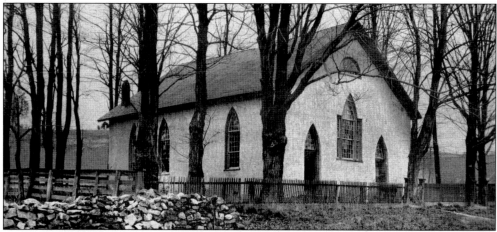

On May 15, 1819, sixty-two members of the First Presbyterian Church of Hardyston (then located in Sparta) petitioned to form their own church under the name of the North Presbyterian Church of Hardyston. The first church they built was destroyed by fire in 1830. Fourteen months later, on May 6, 1831, the new stone church was consecrated. This church stood until it was demolished in 1958.

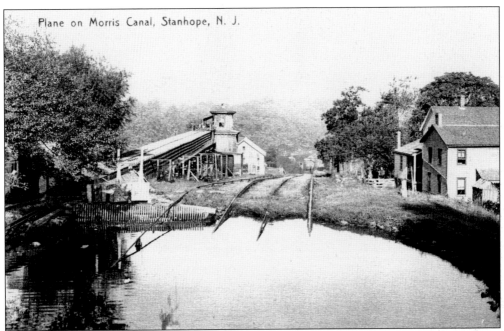

Plane on Morris Canal, Stanhope, N. J.

One of the greatest engineering projects in the history of New Jersey was the construction of the Morris Canal (built between 1825 to 1831). When the canal was finished, it connected Newark to Stanhope and down to Phillipsburg. This *c.* 1905 view, looking toward Waterloo, shows Inclined Plane No. 2 West in Stanhope.

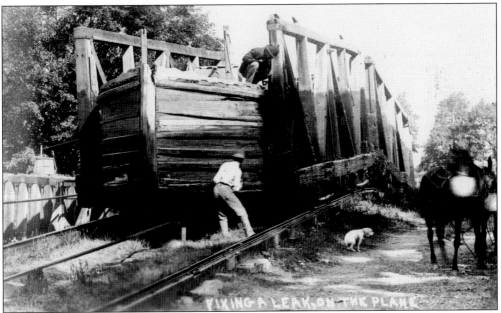

This photograph offers a closeup of a canal boat in one of the cradles that brought the boats up and down the inclined planes. Repair work is being done on the hull of the boat below the waterline. While the repair is going on, mules that were used to pull the barge along the canal are standing off to the side with their feed bags.

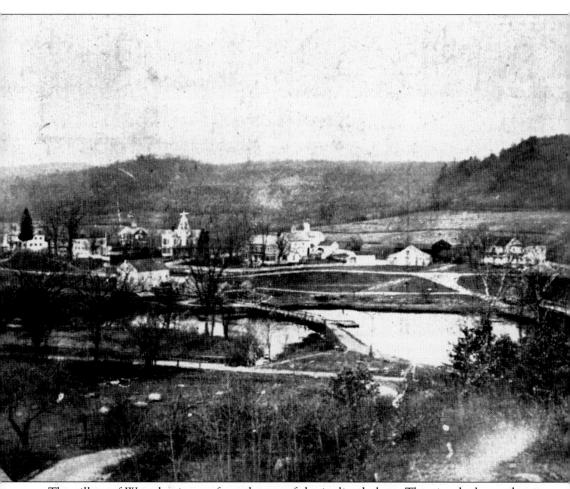

The village of Waterloo is seen from the top of the inclined plane. The view looks northwest c. 1907. The canal basin, tow path, general store, Methodist church, mill and private dwellings, and stage stop with barn are spread out before the viewer. The bridge in the middle allows the mules and drivers to guide the boat toward the canal once it reaches the bottom of the plane. Waterloo was known as Andover Forge in the 18th century. The hamlet was described by Thomas Gordon in 1834 as being located "on the N. bank of the Musconetcong river, at the juncture of Lubbers run with that stream. [It] is situate in a very narrow valley, and has around it a store, sawmill, and some 6 or 8 dwellings."

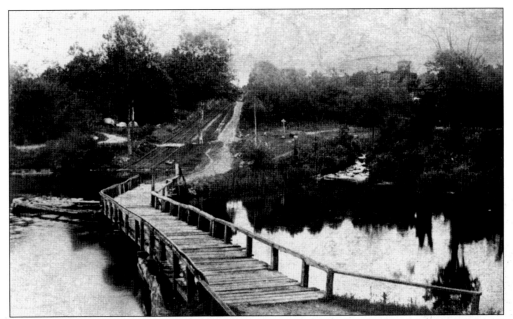

Inclined Plane No. 2 West can be seen in the background, leading toward the village of Waterloo in this *c.* 1906 image. The boats coming down the plane would be met by the mules and driver, who would work the boat around the left side of the bridge and back into the canal, through a lock.

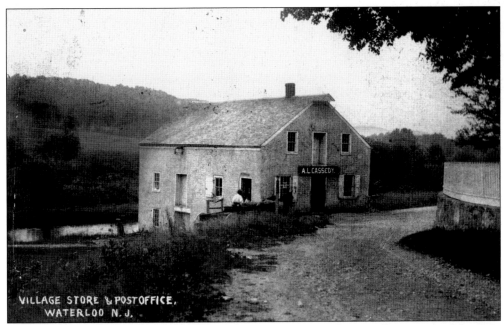

This 1907 photograph shows the Waterloo general store and post office, operated by A.L. Cassedy. The general store was located alongside the canal so that goods could be shipped in from the boats and so materials purchased by the boat captains could be easily transported out. Postal service here extended from December 1847 to February 1916, when service was transferred to Stanhope.

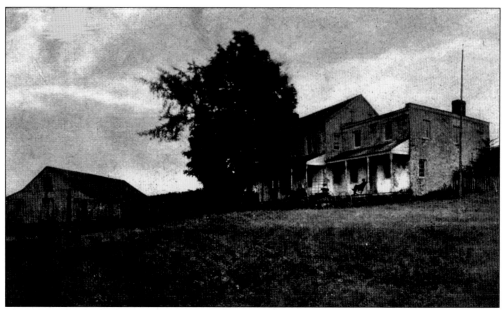

Waterloo also had a stage stop, with accommodations for a change of the teams pulling the stagecoaches. This photograph, taken in 1908, shows the tavern and barn that were located on the eastern end of the village.

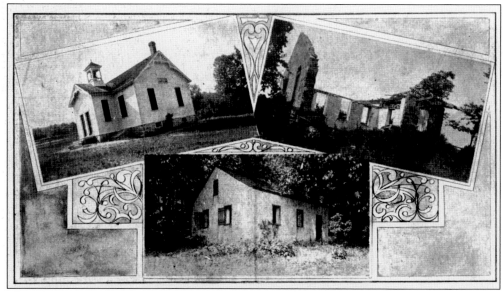

This 1908 postcard shows all three of the buildings that were schoolhouses in the village of Waterloo. The ruins in the upper right corner date back to the late 1700s, while the bottom schoolhouse was opened in 1842, according to the postcard. The school shown in the upper left corner was opened in 1901, and is noted as the new building.

Three

INDUSTRIALIZATION AND AGRICULTURAL DEVELOPMENT

Huntsville Bridge, Huntsville, N. J.

Industrialization arrived in Sussex County in the mid-1850s with the advent of the Sussex Railroad. This railroad was chartered *c.* 1850 with an authorization to build a line connecting the mines in Andover to the Morris Canal. The line began at Waterloo, where it tied in with the canal and the Morris and Essex Railroad. The railroad also extended north into Newton. By the end of the 1850s, it arrived in Branchville. With the railroad and improvements to the county road network, both farmers and businesses in the county began to prosper and grow.

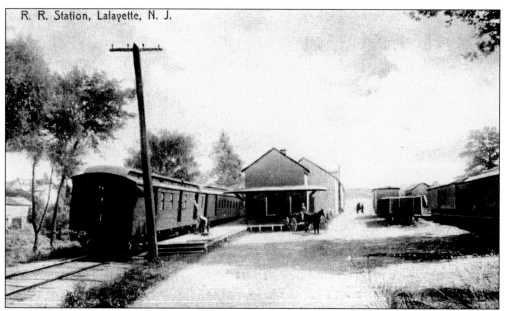

The Delaware, Lackawanna & Western Railroad (formerly the Sussex Railroad) connected Lafayette's farms and businesses with the major cities in the East (Newark and New York City) just as it did the other towns along the line. In this postcard from 1912, the afternoon train sits in the station. The Alderney Dairy Company's creamery, with its own siding, can be seen on the far right.

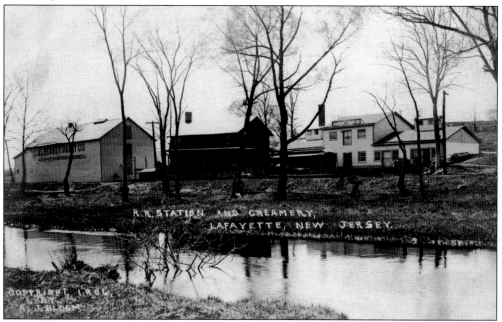

The Delaware, Lackawanna & Western followed the Paulinskill when approaching Lafayette and ran along the south side of Main Street in the village. The station was built a little east of the village and was surrounded on both sides by a creamery complex. In 1906, when Alva Jackson Bloom took this photograph, the Alderney Dairy Company was doing a thriving business. The creamery was demolished in October 1938.

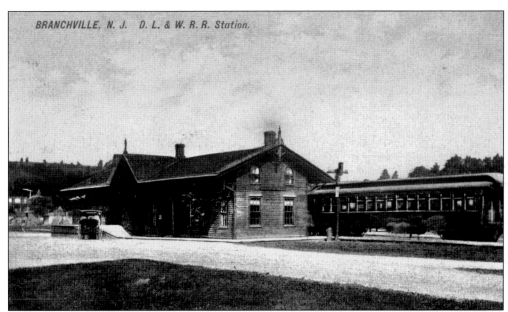

BRANCHVILLE, N. J. D. L. & W. R. R. Station.

Following the arrival of the railroad in Branchville, 40 buildings were constructed on Wantage Avenue. Broad Street was laid out with 20 new buildings, including a hotel and several stores. This 1912 postcard shows the railroad station with a passenger train that has just arrived. After the railroad was abandoned, the station was moved to a nearby property. The station collapsed under a heavy snowfall in the winter of 1995–1996.

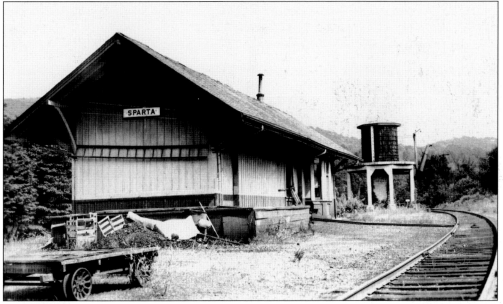

The Delaware, Lackawanna & Western Railroad was not the only railroad in the county. By the late 1870s, the New York, Susquehanna & Western had a line through Stockholm, Beaver Lake, Ogdensburg, Franklin, Hamburg, and Sussex. The railroad pushed a second line down from Ogdensburg to Sparta, Halsey, Swartswood Junction, and Stillwater. The New York, Susquehanna & Western combination passenger and freight station shown here still stands just off Station Road in Sparta.

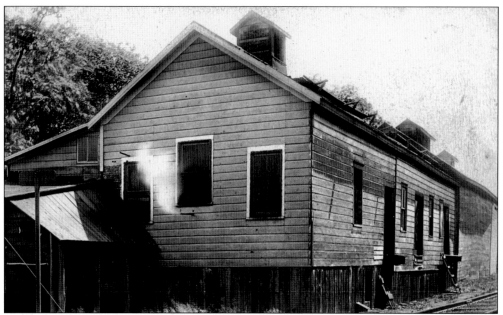

Like many other villages in Sussex County with a railroad line, Stockholm had a creamery that provided a common point for processing and shipping dairy goods produced by local farmers. The creamery was located on a siding that came off the main line of the New York, Susquehanna & Western. This 1910 photograph shows the creamery during the processing of bulk milk, as noted by the steam cloud coming from the pipe beneath the middle window.

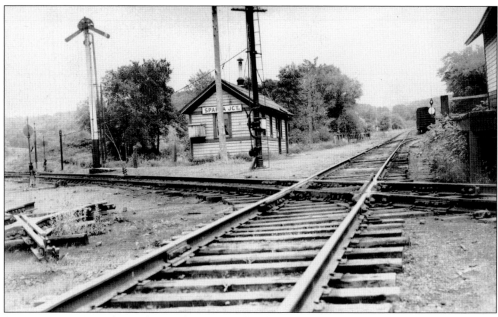

Sparta Junction was located near the western border of Sparta Township, at the southern end of Germany Flats, and was the point of interconnection between the New York, Susquehanna & Western Railroad and the Lehigh & Hudson River Railway. The junction was primarily a telegraph office and train order station. None of the structures remain today.

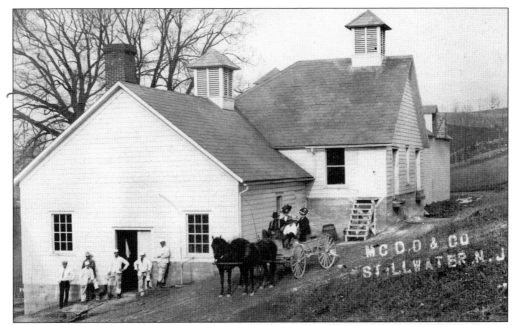

The Stillwater creamery served local farmers by processing milk and shipping it to distant markets on the New York, Susquehanna & Western, which ran nearby. The siding track for the creamery can be seen in the lower left corner of this photograph taken *c.* 1910. The ownership of the creamery changed hands several times. In later years, the facility was owned by Borden's.

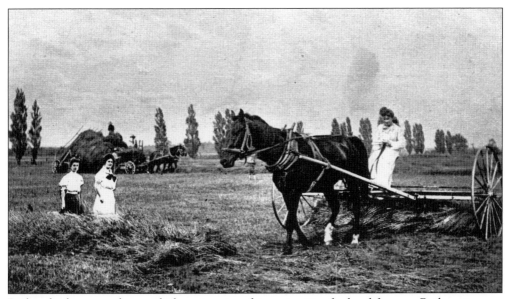

Railroads also opened up a whole new series of opportunities for local farmers. Rail service was able to bring in modern farming equipment that had been unavailable to area farmers and dairymen. In this photograph, a woman is driving a horse-pulled hay rake. It is doubtful, however, that people would have worn their good clothing to do such work.

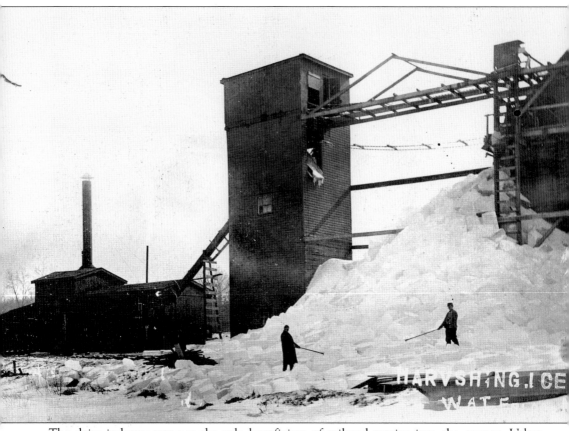

The dairy industry was not the sole beneficiary of railroad service into the county. Urban residents with refrigerators (also known as iceboxes) required a constant supply of block ice in order to preserve food. The railroads provided the means for shipping the ice in bulk to the cities, which in turn brought about a whole new industry—ice harvesting and warehousing on a very large scale. In this view, ice blocks have already been cut and are being put into the icehouse for storage. It was hard and numbing work. The ice on the lake first had to be marked out and scored. A horse-drawn saw was then used to cut the ice into blocks, which had to be moved to the elevator at the icehouse.

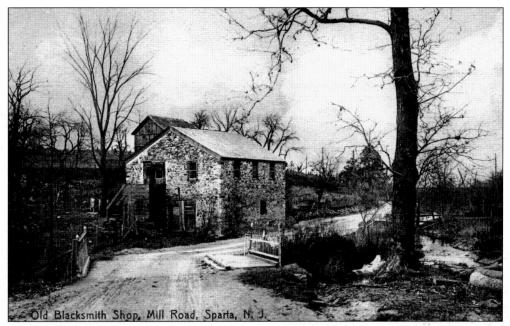

Old Blacksmith Shop, Mill Road, Sparta, N. J.

Certain old trades were not immediately affected by the railroads. Throughout the 19th century and into the 20th century, the skills of a blacksmith were still in demand. This 1911 postcard shows the stone blacksmith shop on Mill Road (now Station Road) in Sparta. The building is still there but is used by a water-purification company.

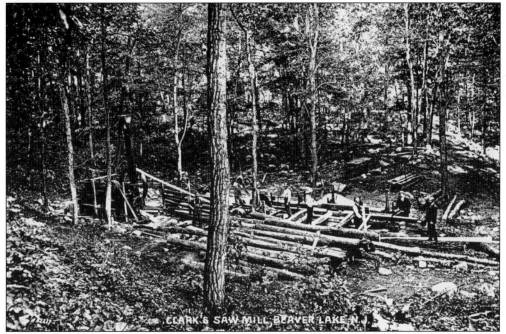

CLARK'S SAW MILL, BEAVER LAKE, N. J.

Sawmills set up on location were not uncommon. This afforded the sawyer the ability to operate close to the stand of timber being worked on. The Clark sawmill, near Beaver Lake in Hardyston Township, is seen in this 1910 postcard image. Timber cut here was used by local builders or was shipped by rail to the cities.

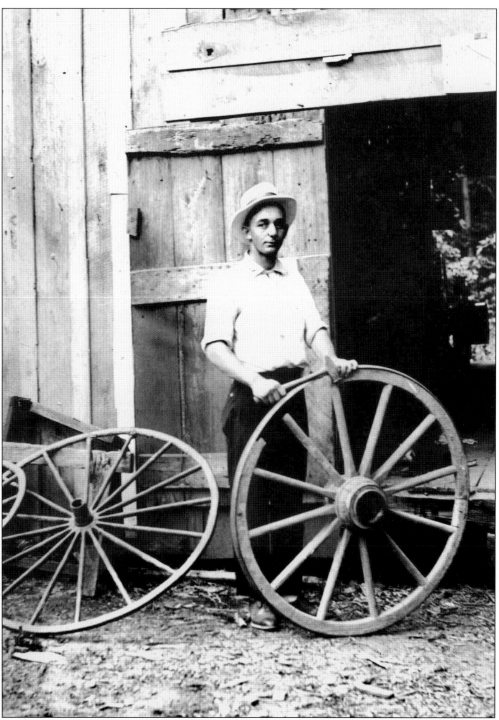

Herman Trousdale poses in front of his wheelwright shop with a wood-spoke wheel in need of repair. Wheelwrights continued to ply their trade into the 20th century, despite the arrival of the automobile. Farm wagons and machinery still needed to be repaired, keeping wheelwrights and blacksmiths employed. Eventually, they adapted their trades to meet changing demands.

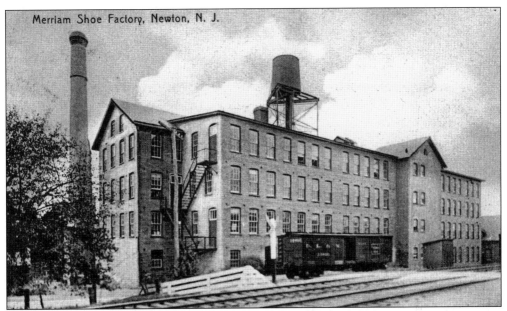

Rail transport was crucial to industrial development. Therefore, like the creameries, the Merriam shoe factory was built next to the railroad tracks with a private siding for bringing in raw materials and shipping out finished goods. By the time this postcard was printed in 1907, the factory had grown considerably and a steam plant had been added. By 1913, Merriam employed 550 workers.

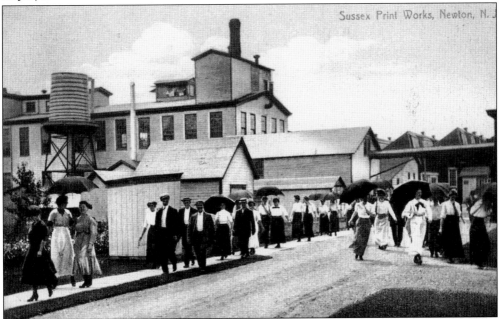

On October 25, 1895, ground was broken for the Sterling Silk Mill complex in Newton. Like the Merriam shoe factory (across the street), the silk mill relied on the railroad for shipping goods both in and out. Employees of the company leave the factory for lunch in this photograph taken during the summer of 1912. Many of the women carry umbrellas to provide protection from the sun.

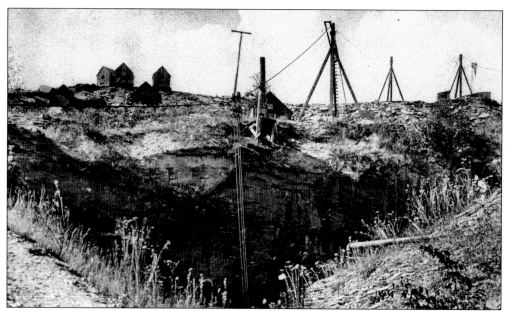

This early-20th-century postcard shows the Newton slate quarry with the hoist lines descending into the pit. The quarry, located on West End Avenue about a mile south of the center of town, operated from the late 19th century until 1923. It provided slate for building roofs in the area and also shipped slate shingles out on the railroad. Slate quarries were also located in Lafayette and Sussex.

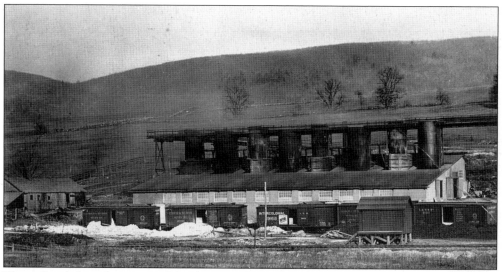

The railroads heavily competed for shipping the end products of other quarrying and mining operations. The quarrying and processing of lime in the county was a major industry. One of the processing plants where the lime was burned was located near Hamburg alongside the main line of the Lehigh & Hudson River Railway, as seen in this 1909 photograph.

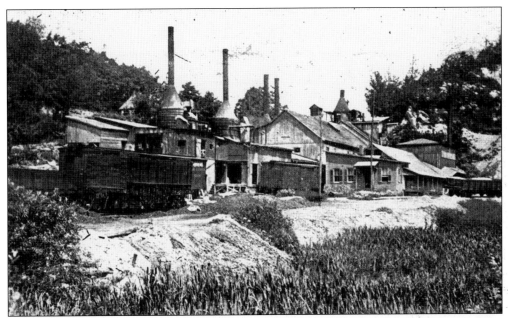

With the arrival of the railroad in McAfee in 1871, large-scale quarrying and burning of the area's limestone became practical. Limestone was quarried on the Chardavoyne farm, located at McAfee, and was then burned in kilns. The final product was put in barrels and shipped out by railroad, as seen in this 1906 postcard image.

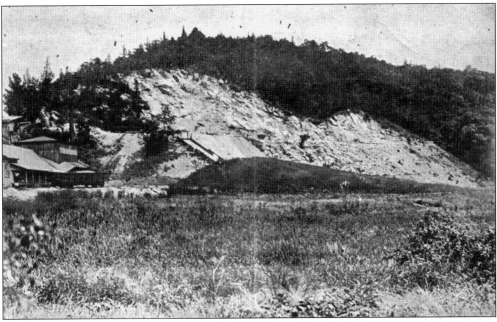

The open face of the limestone quarry shows the massive area that was being worked by the New Jersey Lime Company in 1906. By the time of World War I, the limestone in McAfee was being solely quarried for the use in the blast furnaces of the Bethlehem Steel Company in Pennsylvania. It was reported that 20 or more gondola rail cars were being shipped out daily at that time.

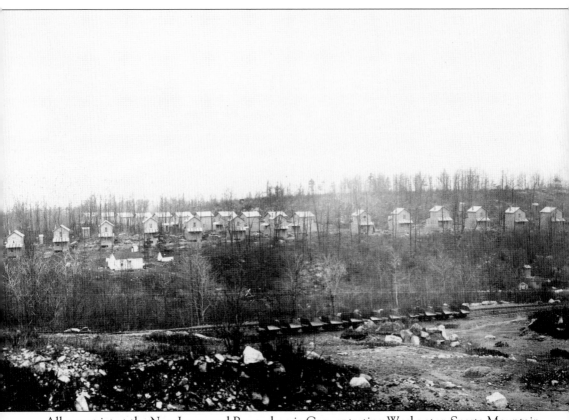

All was quiet at the New Jersey and Pennsylvania Concentrating Works atop Sparta Mountain when this series of six photographs was taken *c.* 1901. This complex was designed and built by Thomas Edison, who had an interest in magnetic separation of iron ore from rock. He developed a series of working models to confirm that an electromagnet could be used in conjunction with a process of crushing the rock bearing the ore. By 1889, Edison had decided to enter the business of "concentrating" iron ore and sent out prospectors to find a site for the operation. The geological surveys extended from the St. Lawrence River south to the Potomac River in areas known to have magnetite ore. The field crews crossed and recrossed the mountains in intervals of one mile, identifying several large deposits. Edison acquired around 2,250 acres of land on Sparta Mountain near the village of Ogdensburg.

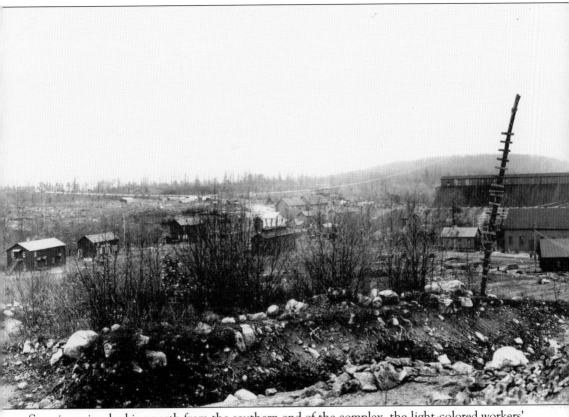

Seen in a view looking north from the southern end of the complex, the light-colored workers' housing on the left was referred to as "New City." More residences, known as "Cuckoo Flats," are visible in the middle of the photograph. The large structure on the right, behind the telephone pole, is one of three stock houses, where the crushed iron ore could be stored before being processed further. Each stock house had a capacity of 16,000 tons of ore, which created a reserve supply of materials that would permit interruption-free production of the final magnetite briquettes.

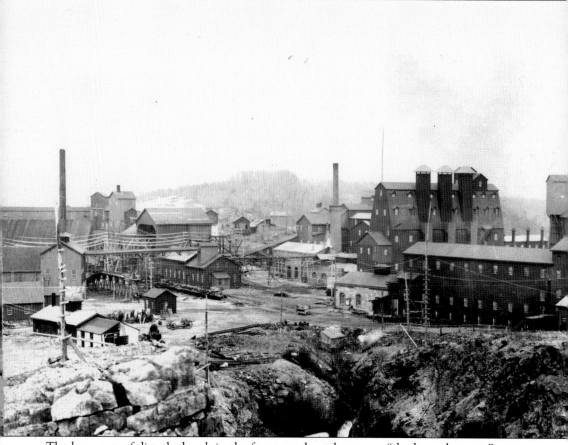

The large area of disturbed rock in the foreground was known as "the horseshoe cut," a source of the ore quarried for processing. The buildings in the middle of the picture include the boiler and machine house; the ore mill, engine, and boiler house; the machine shop and storage building; the assay office; a portion of the stock house (far left, behind the smokestack); the power station; and the carpenter and pattern shop. Several of the empty ore skip cars can be seen in front of the crusher engine house and dry house.

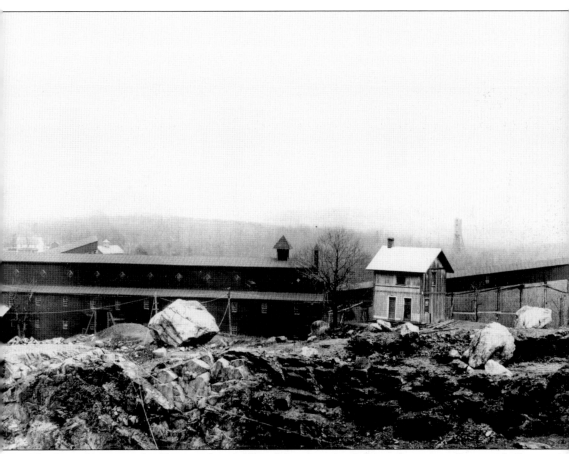

The long three-story building in the middle of the photograph housed a series of ore crushers used before the finely broken up iron ore was sent to the "bricker" building. A portion of the above-ground enclosed conveyor system appears on the right.

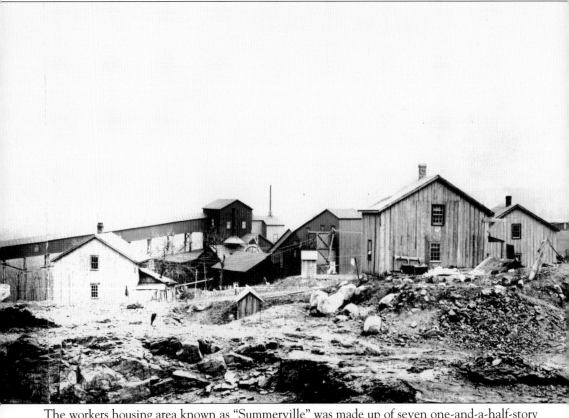

The workers housing area known as "Summerville" was made up of seven one-and-a-half-story frame structures, with a privy located near each dwelling. In the background, the conveyor system delivers the finished crushed ore to the "bricker" building, where the briquettes were formed and then loaded into railroad cars for shipping to furnaces to produce steel.

Operations had begun by 1891, when 117 tons of powered magnetite were purchased by the Lackawanna Iron and Coal Company. The complex grew incrementally, with changes being made to improve the manufacturing process. Production was halted in 1893 by a national financial panic. Production resumed in 1896, but Edison had by then realized that the iron ore discovered in Minnesota was easier to mine and of a higher grade and cost less per ton to deliver to the Pennsylvania steel furnaces than he could. On September 30, 1900, Edison formally closed down the plant, having lost millions of dollars and having laid off some 400 men.

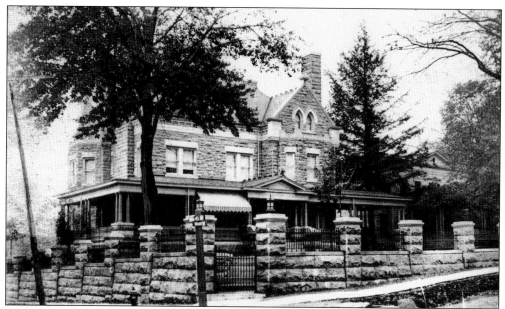

The growth witnessed by the county between 1860 and 1900 was not limited to manufacturing, mining, and agriculture. Village and town centers began to develop and expand. Services and public improvements were implemented, reflecting a new civic pride. Many houses, such as the Bentley Mansion (on Main Street in Newton), were built to reflect newfound wealth.

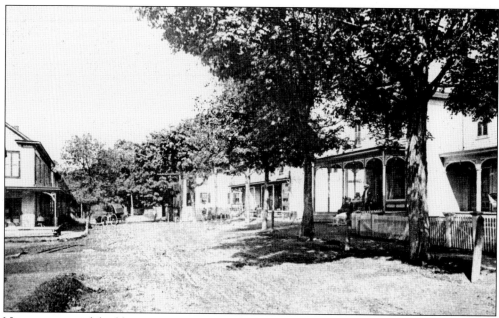

New commercial buildings were constructed along Main Street in the village of Lafayette during the last four decades of the 19th century. This turn-of-the-century view looks west in the business section, with the midday shade being cast by large trees on hard-packed dirt streets. This part of present-day Route 15 was not paved until well into the 20th century.

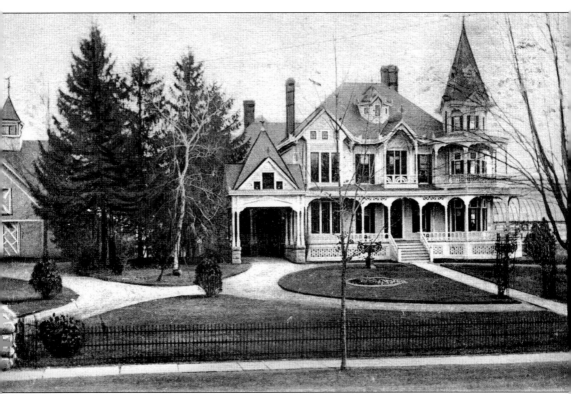

Newton shoe manufacturer Henry W. Merriam acquired a triangular tract of land at the corner of Main Street and Maple Avenue in June 1883. The following month, workmen began blasting the slate ridge to create a level area on the lot in preparation for Merriam's new showcase dwelling. When the house was completed the following year, the Merriam house had the distinction of being the largest private dwelling in Sussex County. In 1889, Merriam enlarged the house, adding a 60-foot hothouse and conservatory for his wife, who was an invalid. The house is a perfect example of a Victorian gentleman's country villa, with its exuberant Queen Anne–style turrets, porches, and different types of siding.

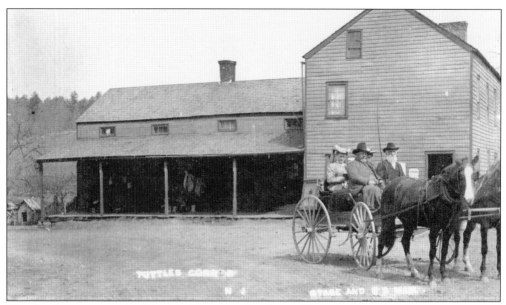

The farmhouse situated at Tuttle's Corner in Sandyston Township stood at the intersection of present-day Route 206 and the road leading to Layton until the early 20th century. The U.S. Post Office Department maintained a station here from 1844 to 1864 and from 1871 to 1879. The stage that carried the mail appears to be leaving and heading back over the Kittatinny Mountains toward Branchville.

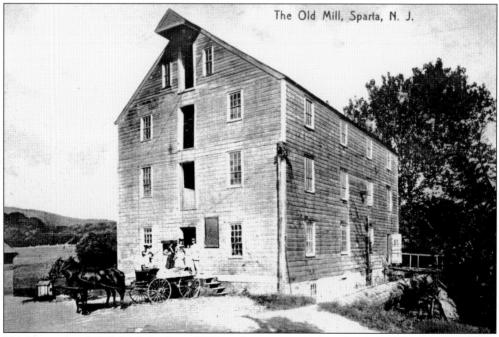

The Titman and Folk Mill, built in 1837 at the corner of Main Street and Station Road, was one of the largest mills in the township. The mill's turbine was driven by water piped from the Wallkill River in the wooden barrel flume seen to the right of the mill. Today, only the foundation of the mill survives as the base of Sparta Radio and TV.

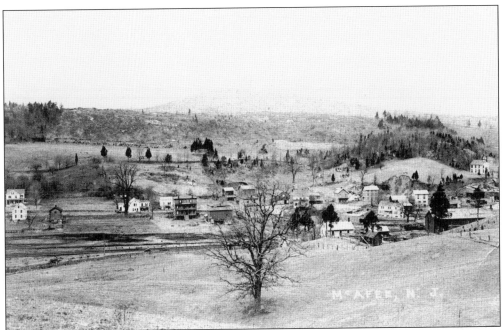

Development of communities was not restricted to the larger towns. McAfee, in Vernon Township, was first settled in the mid-1700s. Growth here was not realized until 1871, when the Sussex Railroad extended a line here, primarily to transport the iron and limestone being mined. This photograph shows the hamlet *c.* 1900, with the lime works seen on the far right.

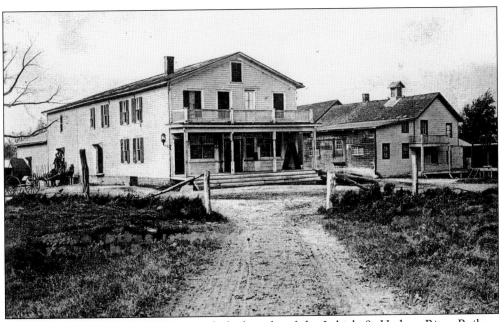

A creamery was built along the recently laid tracks of the Lehigh & Hudson River Railway *c.* 1880. The creamery was replaced in 1894 with the building seen in this postcard image. Milk cans are piled up on the loading dock on the right. Mott's store was located next to the creamery. Note that both buildings have side freight bays to facilitate loading goods into wagons.

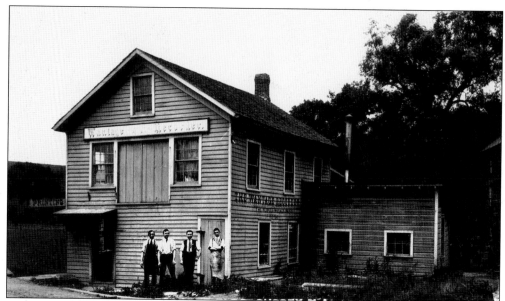

Sussex Borough also experienced growth during the last four decades of the 19th century. The Wantage Recorder, a weekly newspaper, had its editorial, news, and advertising offices and printing presses contained in this building on Sussex Avenue, next to Clove Creek. The newspaper was in print between January 1894 to 1943.

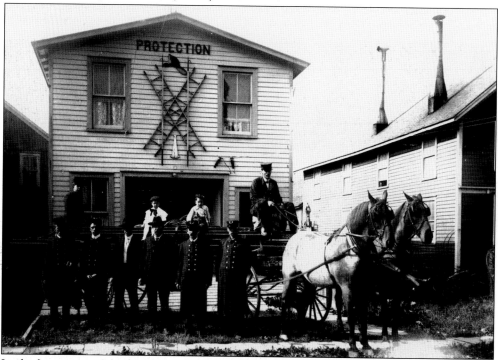

In the latter part of the 19th century, Sussex Borough (then Deckertown) had the Protection Hook and Ladder Company providing firefighting services to not only the borough but the outlying areas as well. This c. 1895 photograph shows the state-of-the-art horse-drawn ladder wagon, members of the fire company, and the firehouse located on Hamburg Avenue.

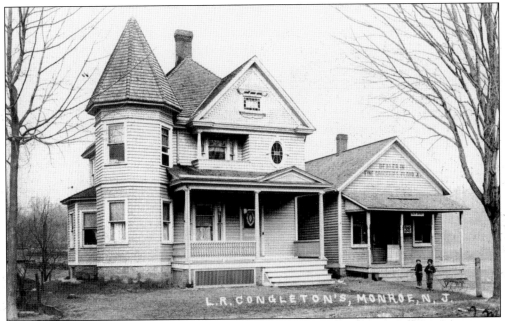

The hamlet of Monroe is located in the northern end of Sparta Township, on the Hardyston border. In the 19th century, Monroe was a thriving community with a store, post office, school, gristmill, and creamery. Monroe also had a station on the Lehigh & Hudson River Railway. This 1909 view shows the store and post office next to the home of L.R. Congleton.

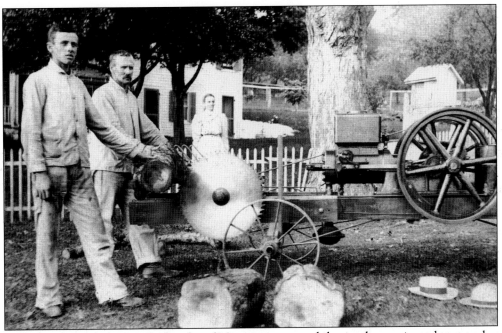

On a farm located close to the hamlet of Monroe, a new mobile circular saw is used to cut a log to proper lengths for a fireplace or kitchen stove. The saw is driven by a wide leather belt attached to a small "hit-and-miss" engine. Such equipment for a farm would not have been readily available until after the arrival of the railroads.

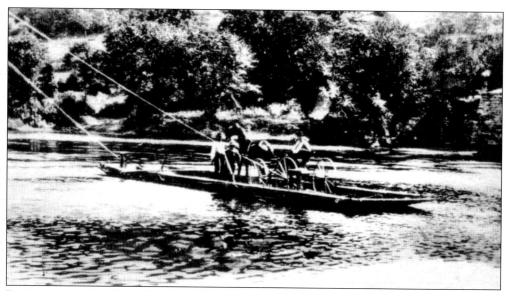

Ferries were used exclusively to cross the Delaware River before bridges were erected, providing a more convenient means of going over to Pennsylvania. The Dingmans Ferry, which was first established by Andrew Dingman in the mid-1730s west of Layton in Sandyston Township, transported people and wagons. The cabled raft crossing continued until the mid-1830s, when the first bridge was built. It was again used in the late 1800s.

In 1912, George D. Price sent this photographic postcard from Sandyston to his cousin J.W. Price in Newton before going home to Walpack Center, where he served as the pastor for the Methodist congregation there. He wrote, apparently after visiting in Newton, "We enjoyed our visit with you. Had some very bad roads. Sarah is quite complaining, seems to be all run down. Shall look for you over the summer."

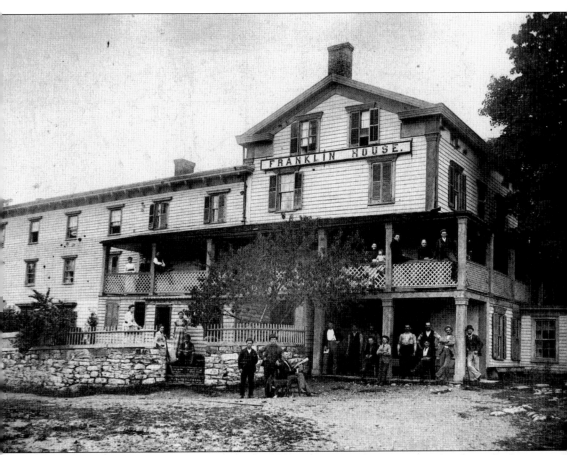

Littell's Hotel, also known as the Franklin House, was the first hotel in Franklin, being built before the Civil War. The design of the main section of the building was influenced by the Greek Revival style of architecture, which was popular during the 1825–1860 period. This early-1890s view shows the hotel staff and guests. Another story was added to the main section of the hotel after the structure suffered damage from the Wallkill River flooding in 1902 and 1903. The building stood on Church Street west of the bridge over the river.

Edward Webb, in his 1872 *Historical Directory of Sussex County,* describes Middleville as a "small post village of about twenty or thirty inhabitants. It contains an hotel and store, and a good-sized building which has been leased at various times for different mechanical purposes." In this view, the Robbins general store is seen with the horse-drawn carriages of local farmers and residents. Three generations of the Robbins family ran this store and post office.

The Booth Brothers knife factory was built in Sussex Borough (then Deckertown) in 1903 after the closing of the original facility in Stockholm in Hardyston Township. The three-year-old factory is shown in this card postmarked January 7, 1907. In 1909, the *New Jersey Industrial Directory* noted that 55 persons were employed here. Eventually, the knife factory was sold out to a concern in Tideout, Pennsylvania.

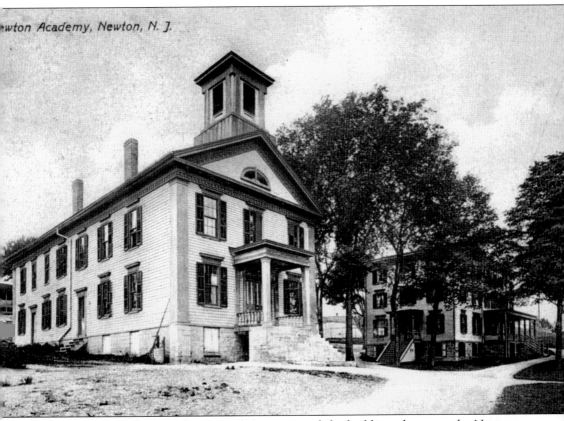

High on the hill overlooking the town of Newton stood the buildings that were the Newton Academy, a private school for boys. When the school originally opened on Liberty Street, it was known as the Newton Presbyterian Academy. In 1853, the trustees moved the facilities to new buildings on what was referred to as Anderson Hill and later renamed Academy Street. The school was renamed the Newton Collegiate Institute in 1855. Judge Henry Huston reported about the school in 1897: "The pupil, and not the class, is considered the unit, so that equal advantages are offered to the bright and the slow. . . . For exercise there is a campus of fifteen acres, while in bad weather, the boys can find recreation in the gymnasium or bowling alley. Nothing that can promote health and comfort has been neglected. The aim of the school is to give each boy an honest and thorough education." The buildings were torn down in 1974.

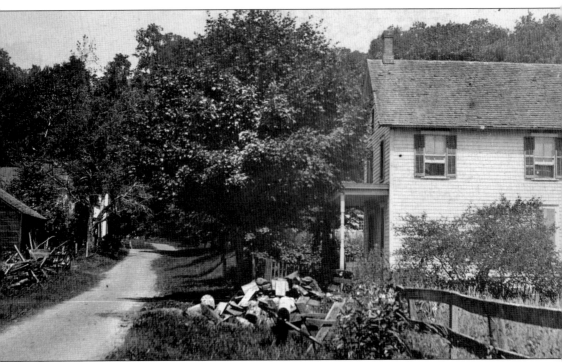

During the period before 1900, many small hamlets and villages in the county flourished and served as the center of life for many individuals. The areas then witnessed a decline, especially after World War II. Walpack Center is an example of such a village. In 1860, there was a school, a Methodist church, cooperage, store, blacksmith shop, and about 24 dwellings. On January 20, 1829, a post office was opened here. Officially known as "Wallpack," the post office was closed in January 1854. It was reopened on January 21, 1854, and was officially redesignated "Wallpack Center" in November 1893. The Methodist parsonage, seen in this 1906 photograph, was built in 1893 after the destruction of the old parsonage by fire. Rev. George D. Price coordinated the efforts to erect the dwelling and served as the contractor for the project. The new 22- by 30-foot parsonage, together with repairs to the barn, cost $1,000. The blacksmith shop is seen in the distance on the left side of the road.

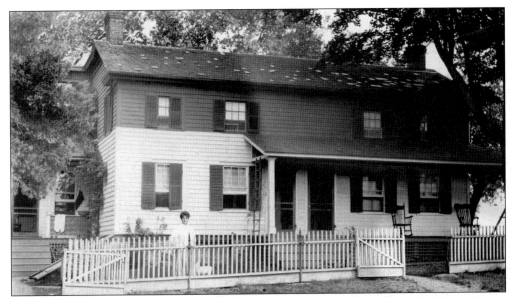

The Emmet Bell house was located east of Walpack Center on the other side of the old iron bridge that crossed the Flat Brook. The farmstead was in the Bell family for many generations, with the house dating from the early 1800s. A member of the Bell family is seen standing behind the picket fence in this 1906 photographic postcard. With the two front doors, it would appear the house accommodated two families.

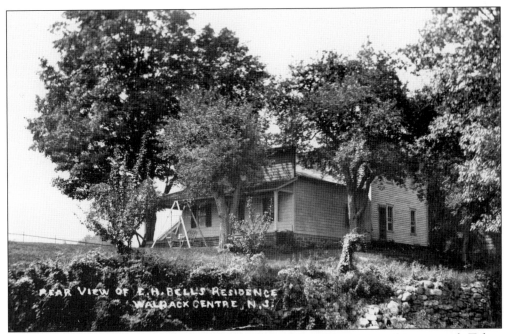

REAR VIEW OF E. H. BELL'S RESIDENCE
WALPACK CENTRE, N. J.

The rear of the Emmet H. Bell house is shown in this 1906 photographic postcard. Taken during the summer, the photograph shows a swing near the back porch under the shade of a large tree. The house burned to the ground many decades ago.

The house of E.S. Rosenkrans and his store are shown in the 1925 postcard view of the upper portion of Main Street in Walpack Center. The design of the house indicates that the building was constructed before the Civil War.

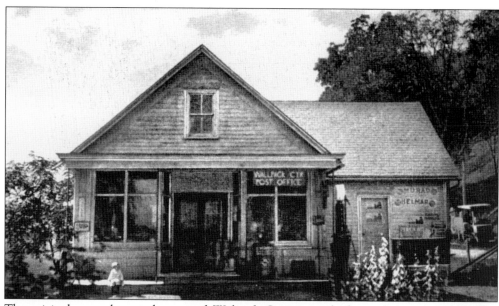

The original general store that served Walpack Center was built on this site c. 1850. The general store shown in this postcard view was built in 1915, after the first store was destroyed by fire. The new store was slightly smaller but was erected in the same foundation. For decades, the general store was the center of activity for the community.

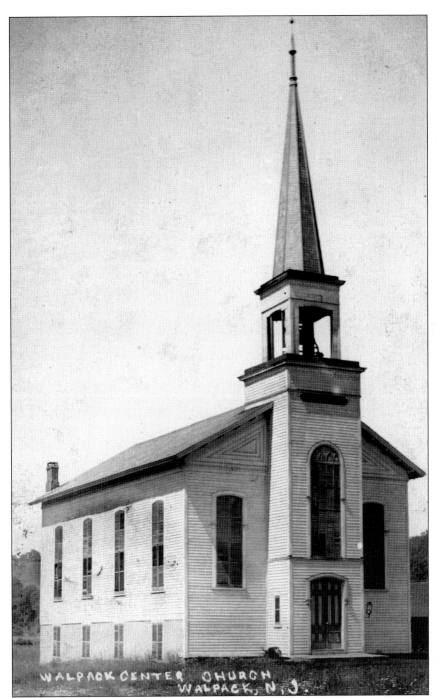

WALPACK CENTER CHURCH
WALPACK, N. J.

In 1837, a stone church was erected (by mostly volunteer labor) on property donated by Robert Bell in 1834. In 1872, the old stone church was deconsecrated, having been replaced by the imposing two-story wood-frame structure in this 1906 photograph. The church, measuring 38 by 60 feet, was erected on land donated by Jacob S. Roe. The siting placed the church closer to the village and on higher ground. The top of the spire, which was 65 feet above the ground, was taken down and replaced with a much shorter cap for the belfry by the 1920s.

59

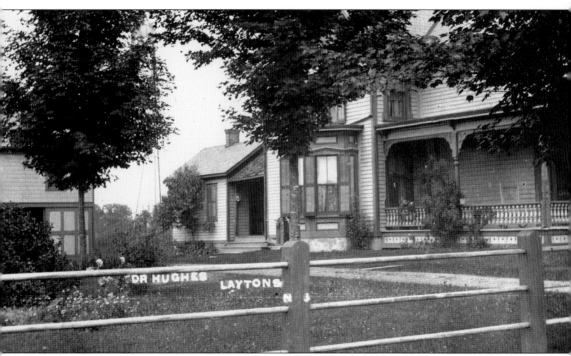

North of Walpack Center, the village of Layton is situated in Sandyston Township. Layton was first settled c. 1800 by John Layton and was known as Centerville. The Little Flat Brook, which provided the source of power for early mills, runs through the center of the village. Like Walpack Center, Layton also thrived in the 1800s, as witnessed by this high-style Victorian dwelling and barn, which belonged to Dr. Morgan Daniel Hughes at the beginning of the 20th century.

Four
SUBURBAN DEVELOPMENT

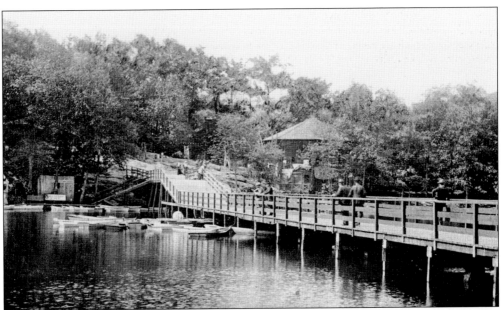

The beginning of the 20th century denoted the start of modernization in Sussex County. During the first 50 years, the county witnessed business growth, major transportation improvements, development of seasonal lakefront communities, school and public works improvements, the worst economic depression ever to take place, and two world wars. In 1900, the Delaware, Lackawanna & Western Railroad leased a 30-acre tract of land (known as Frenche's Grove) on Cranberry Lake and created an amusement park. Massive piers supported the wooden walkway leading from the train station up to the new park, as seen in this 1907 image.

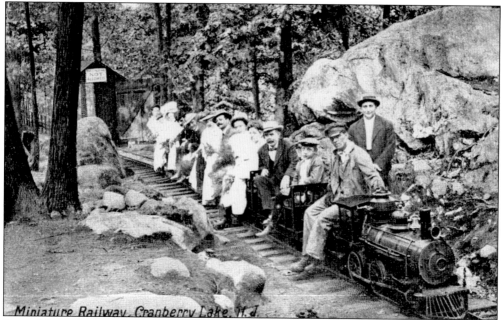

Miniature Railway, Cranberry Lake, N. J.

One of the major attractions at the amusement park was this miniature railroad. The train ran for about 1,000 feet, passing over trestle-spanned ravines and around large rock formations. The train was pulled by a miniature live steam engine, which was built in the Lackawanna's Kingsland engine-erecting shop. The engine replicated the classic American 4-4-0 locomotive type. It weighed about 600 pounds and was around 64 inches long.

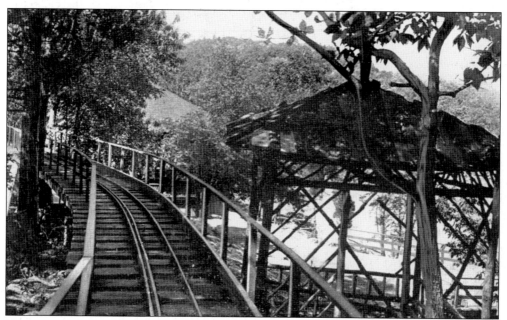

Here is one of the many trestles that carried the miniature railroad over a large ravine. The narrow-gauge track spanned only 14 inches and included an inside safety rail to make sure the train stayed on the tracks. Alongside the trestle is one of the many Adirondack-style pavilions that overlooked the lake.

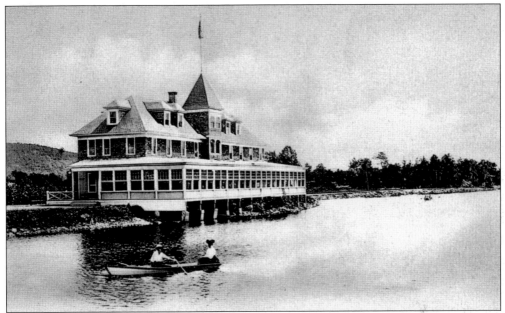

The Pavilion, pictured in this 1908 image, was a hotel built in 1903 by the railroad to provide for overnight accommodations for holiday and weekend tourists coming up from the city to the Frenche's Grove park facility. This tranquil scene was shattered when the hotel was destroyed by fire on December 4, 1910. The railroad did not rebuild the structure, as the 10-year lease on the resort property was almost up.

With the exception of the massive dance pavilion at Frenche's Grove, the refreshment stand served as a focal point for the visitors who had traveled a long distance from the city by rail. Like a number of other pavilions on the site, this one also overlooked Cranberry Lake. This very quiet nook in the park could get boisterous depending on the number of travelers who happened to come up on a given day.

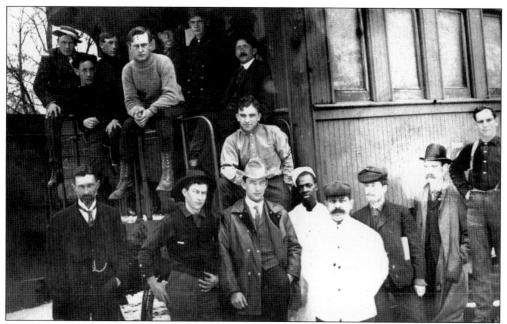

The Delaware, Lackawanna & Western Railroad was also planning the single largest undertaking in its history. Plagued by problems of getting large amounts of coal from Pennsylvania to the Newark and New York City areas, the line decided to build a new route that was straighter and flatter and had no grade crossings or tunnels. It was the job of the field survey team, pictured here, to lay out this new line through Sussex County.

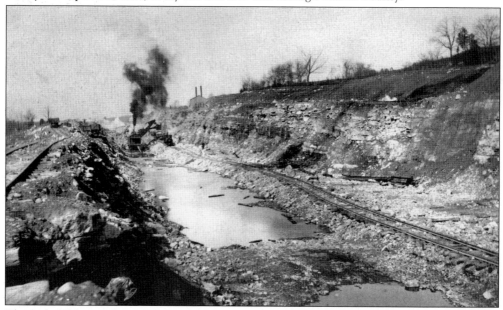

The railroad knew, from the design of the new line, that massive amounts of stone fill were going to be required. The Lackawanna acquired more than 700 acres of less-than-prime nearby farmland in order to blast out and dig up the rock fill that was needed. In this view, a borrow pit has been created and a temporary track installed for the hopper cars to be run in, filled up, and taken out again.

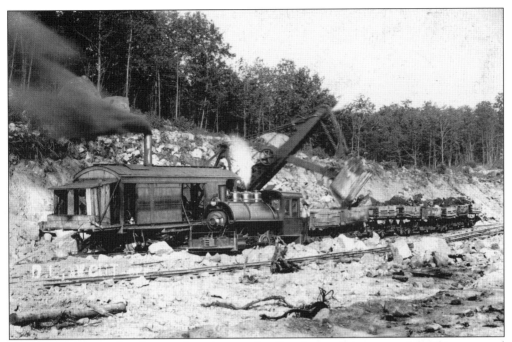

A track-mounted railroad steam shovel is seen loading shot rock into one of the skip cars used for transporting the stone and soil to the areas being filled. Each car held about three cubic yards of material.

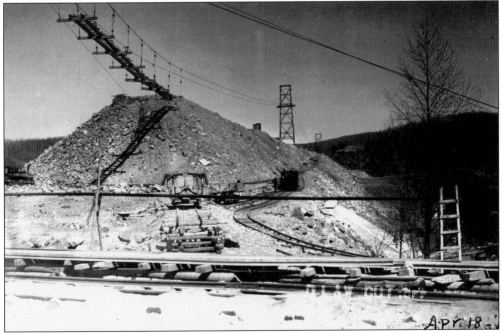

In order to extend and raise the fill, the loaded skip cars were backed onto the cradle. This cradle was a set of railroad tracks suspended by steel wire strung between two large towers, much the same as a suspension bridge. Once everything was in place, a worker would crawl out alongside each car and manually release the hopper, dumping the rock and soil over the side.

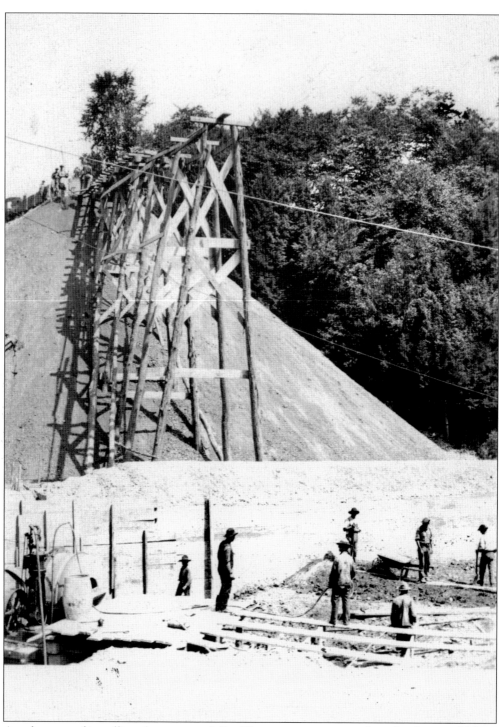

Another way of installing the stone and dirt fill was to create a set of trestles that would form a platform on top for the train cars to back out onto and then deposit the fill. This photograph, taken near Andover Borough c. 1910, shows workers preparing to guide the cars loaded with rock back out onto the slender wooden supports.

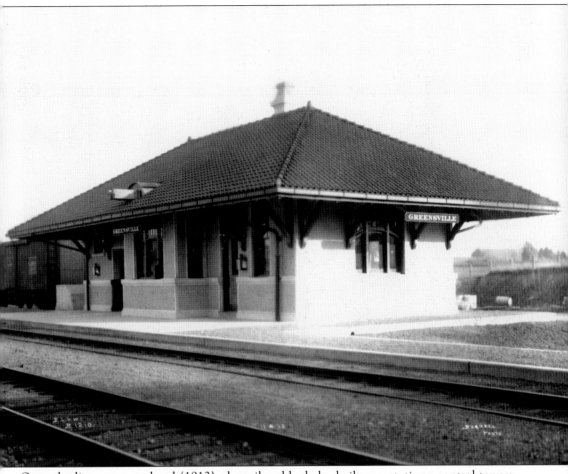

Once the line was completed (1912), the railroad had also built new stations, control towers, bridges, and culverts all out of cast concrete. Located at Greensville (now Greendell), this combination passenger and freight station truly highlighted a major engineering and design achievement that was then without equal in the United States. Like many of the stations built for this new line, the roof was covered in multi-hued tiles.

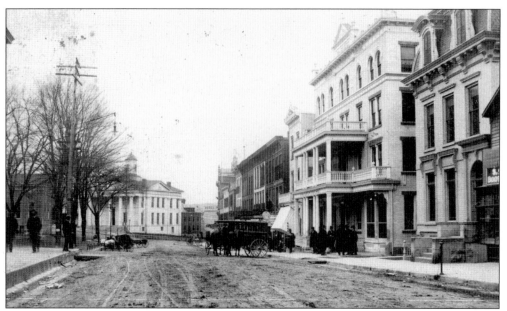

This view looks west on Spring Street, past the Cochran House (with its two-story balcony) to the courthouse. The mansard-roofed building to the right of the Cochran House is the Merchants National Bank. Just visible on the left side of the street is the Sussex National Bank. The two banks later combined and, in 1927, built an imposing new building on the site of the Merchants National Bank.

Transportation in the county was improving at a fairly rapid rate. In order to meet the increasing demand to ship milk from the local creameries, the Delaware, Lackawanna & Western instituted a milk train. Seen here is one of the new glass-lined milk tank cars that the railroad company used for bulk shipping, thus eliminating the need to handle individual metal milk cans.

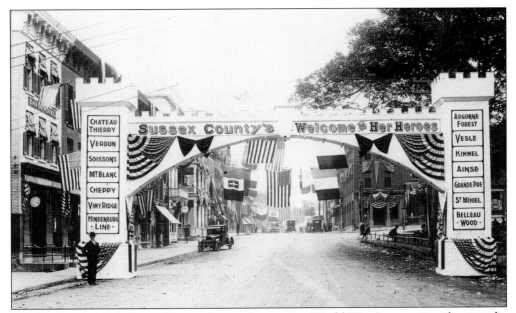

On October 4, 1919, Sussex County honored returning World War I veterans with a parade, free lunch, speeches at Thompson's Field, and a baseball game. The ceremonies ended with "Retreat" at this victory arch. Supper was served to all servicemen, veterans, firemen, bands, and drum corps. Fireworks, vaudeville performances, and a band concert followed the repast. The Sussex County Hero's Day Committee erected the massive wooden arch for the event.

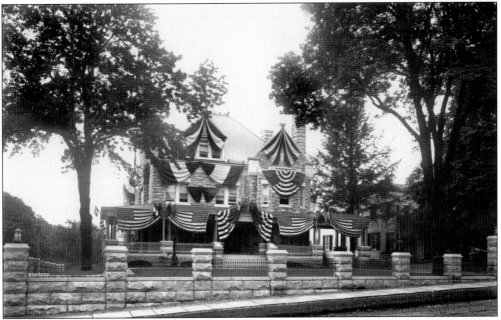

To reflect the sense of patriotism felt by many in the community for the men coming back from "over there," Thomas Bentley, owner of the local silk mill, decked out his Newton mansion with flags and bunting. Here are seen American, British, French, and Swiss flags. Notice that Main Street is still unpaved, although slate sidewalks and cut-stone curbing have been installed in front of the house.

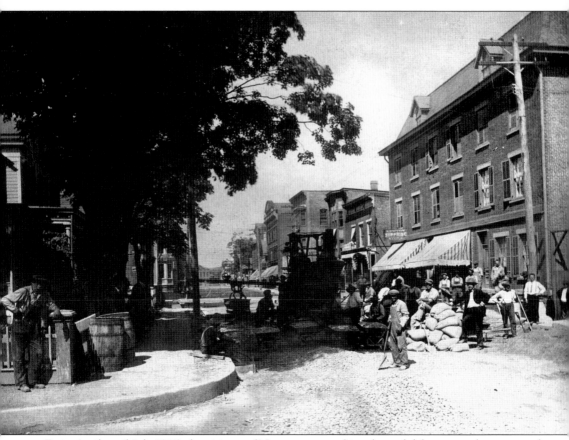

From April until July 1915, the citizens of Newton engaged in a heated debate over the paving of Spring Street. Some local businessmen argued that brick was more durable than concrete and that the surface gave better traction for a horse pulling a heavy wagon. Despite this argument, the town committee moved forward in mid-July. A contract to pave the road in concrete from Union Place to High Street was awarded to the Sothman Company of New York. The L.S. Iliff Company and Hart & Iliff, both of Newton, split the contract to provide the concrete for the project.

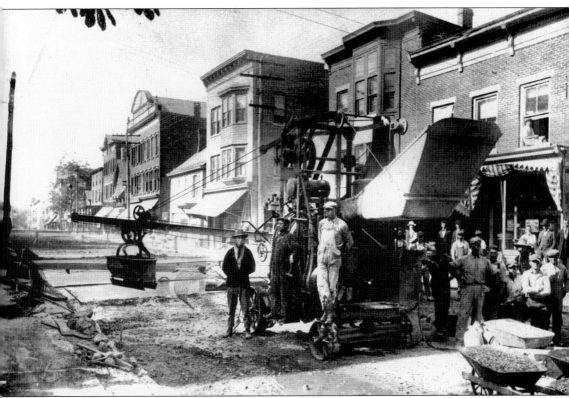

Work began a few weeks after the contract was awarded and was well under way by September, when this photograph and the photograph on page 70 were taken. Here, the workmen pose next to their combination mixer and spreader. When the machine was in operation, they would dump barrow loads of aggregate into the large moveable hopper and then raise it to add the stones to the cement in the mixing drum. The finished concrete was then poured into the bucket on the extended boom and dumped in the appropriate place. The wet concrete was then smoothed out by the laborers.

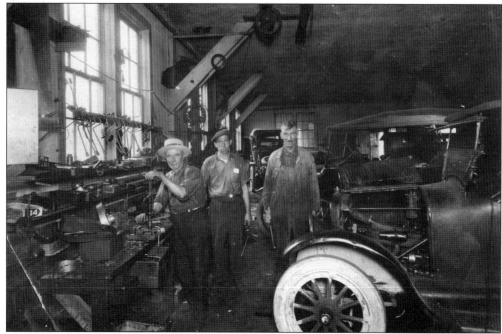

Keeping up with the changing times, blacksmiths had to learn how to repair the horseless carriage and to do new types of work. Certain mechanics, such as Damian Broda of Newton, stayed ahead of the demand. He modernized and completely reoutfitted his repair shop on Water Street. Seen here with two helpers, Broda was the first automobile mechanic in the county.

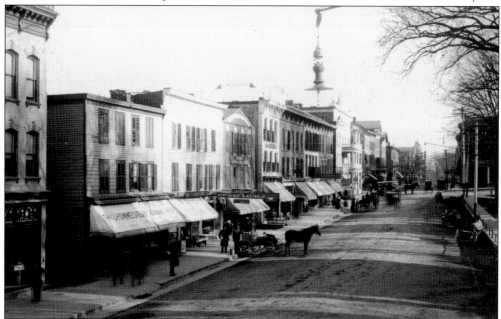

Public improvements were beginning to be completed at an increasing rate. In this 1907 view from the county courthouse, large slab-slate sidewalks, cut-stone curbing, and streetlights have been installed on Spring Street. The lights were suspended from a utility pole with a pulley that permitted them to be lowered to the ground for repair work.

Cor. of High and Liberty, Newton, N. J.

These street improvements were carried on throughout Newton, including High Street. Like many streets in town, the influence of Victorian architectural styles is evident. Hitching posts for horses and cut-stone carriage steps are seen at the curb line of the dirt road.

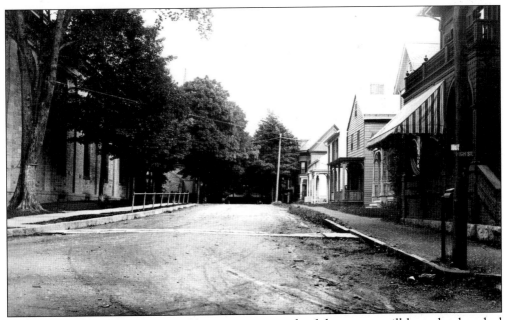

Church Street, one of Newton's older streets just south of the square, still has a hard-packed dirt road in this 1907 photograph. Although curbs and sidewalks have been installed by this time, a concrete roadway will not be installed for another 10 years.

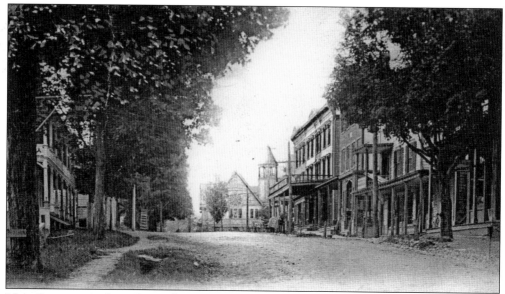

Main Street in Andover Borough was a thriving business area when this postcard was made in 1906. The Methodist church is seen at the southern end of the street, with the Andover Hotel on the left and retail businesses with apartments above flanking the remainder of the road. One block off to the right was the station for the Delaware, Lackawanna & Western Railroad and a creamery.

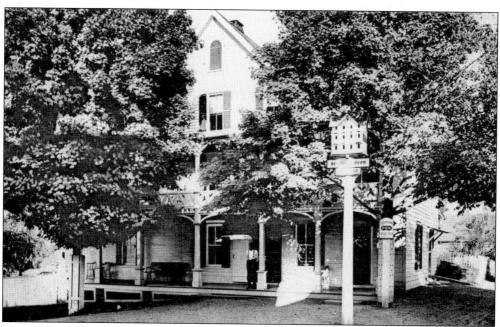

The Andover Hotel, located on Main Street, was easily recognizable in 1908 for its two-story front porch and for the three-story birdhouse that was made to reflect the hotel. The wooden porch on the hotel has been removed, and the birdhouse is no longer on its pole.

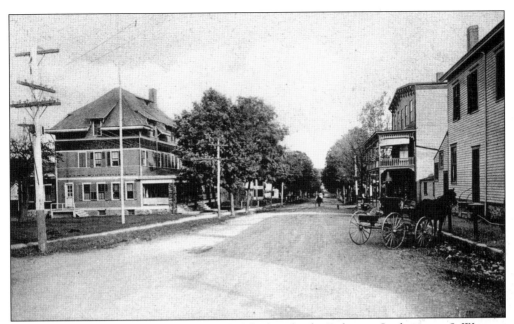

Branchville Borough was the northern end of the line for the Delaware, Lackawanna & Western Railroad. The arrival of the railroad brought with it a major building boom to this little community. In this view looking down Broad Street in 1909, a horse-drawn buckboard stands at the curb alongside the D.L.B. Smith building. Two imposing hotels, located farther down the street, face each other. Neither hotel stands today.

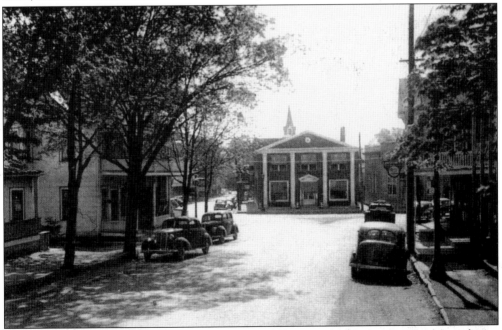

In a view looking down Main Street in Branchville in 1940, the street seems quiet during midday on a summer afternoon. The Selective Insurance Company building is in the center, with the pharmacy on the left and small stores on the right. The Branchville bank can just be seen to the right of the insurance company building.

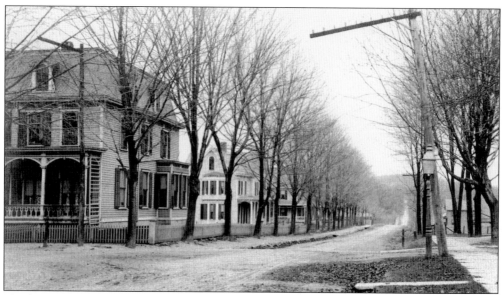

North Avenue in Hamburg, photographed by Alva Jackson Bloom, shows a well-laid-out road with neatly lined trees, slate sidewalks, large houses, and pole-mounted streetlights. This road leads up to Sussex Borough and is known today as Route 23. Bloom, who had his studio on Vernon Avenue in Hamburg, was the only professional photographer in the Wallkill Valley area between 1900 and 1940.

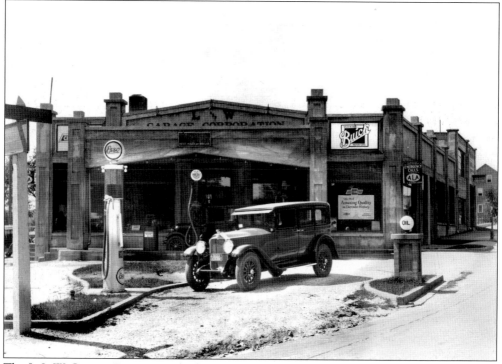

The L & W Garage Corporation had an imposing masonry building on Main Street north of the center of Franklin Borough. Here a driver could buy either Esso or Gulf gasoline and could purchase a Chevrolet or Buick automobile. The garage also provided emergency road service.

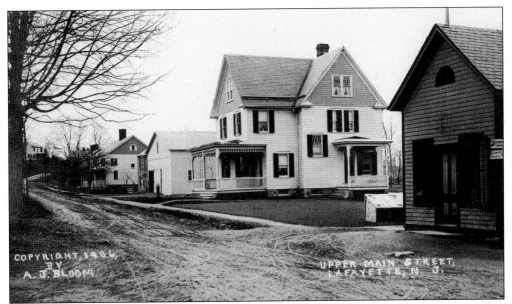

Lafayette, unlike Andover, Branchville, Newton, or Franklin, was a small village surrounded by farms and woods. The village, like the other town centers, made efforts to provide the necessary amenities for residents and the local businesses. In this 1906 photograph by Alva Jackson Bloom, new sidewalks can be seen extending down Main Street (present-day Route 15).

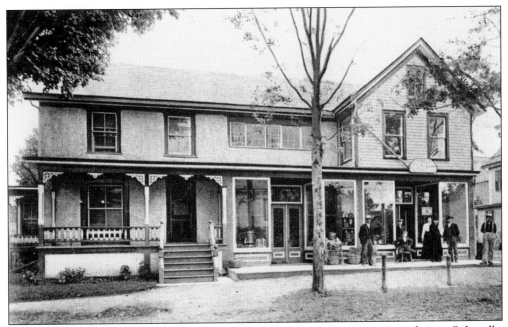

The post office and general store stand facing Main Street in this 1909 postcard view. Sidewalks have not been extended along this side of Main Street yet, with the hitching posts set about 10 feet in front of a walkway built for the store and post office.

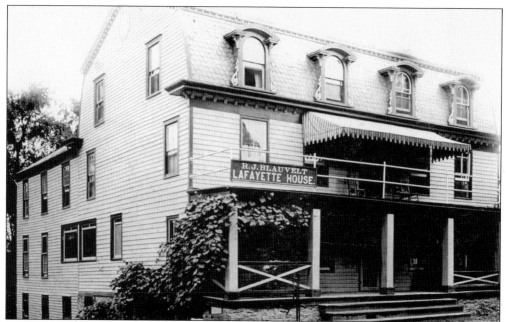

Slightly to the west of the center of the village on Main Street stands the Lafayette House, a restaurant and hotel. R.J. Blauvelt owned and operated this haven for weary travelers, as depicted in this 1907 Alva Jackson Bloom photograph. The business was a gathering point for many social and civic events over the decades. The Lafayette House relocated in the 1980s to Olde Lafayette Village, a shopping center built to the east of the middle of the village.

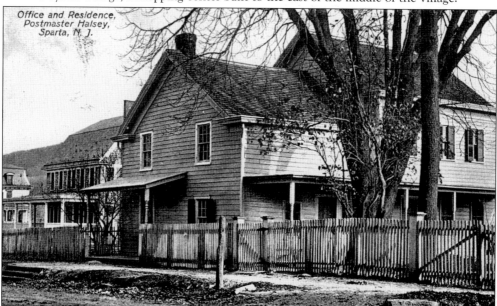

Before the federal government required post offices to be located in publicly accessible buildings, it was not uncommon to find a post office located in a private residence with a separate entrance for the pickup and delivery of mail. Pictured in 1910 is Postmaster Halsey's private home, located on the east side of Main Street in Sparta. The post office entrance faces out onto Main Street.

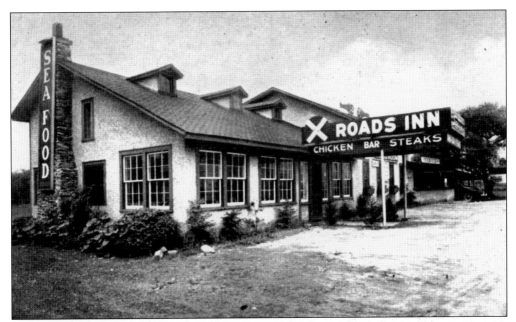

As the day of the automobile came into its own, businesses realized there was an opportunity to offer services to the traveler. Roadside restaurants and tourist cabins began to dot the landscape along the major roads. The Cross Roads Inn, located near Ross' Corner, provided both food and liquid refreshment for the motorist passing through the county. The back of the postcard notes that the inn is famous for seafood.

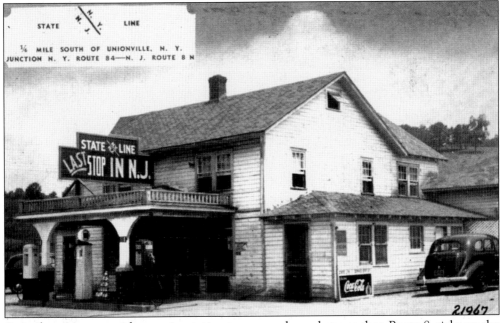

A similar restaurant with a service station was opened on what was then Route 8, right on the New Jersey–New York border, north of Sussex Borough. This 1930s card trumpets general service station work available, as well as cold drinks, light lunches, and refreshments.

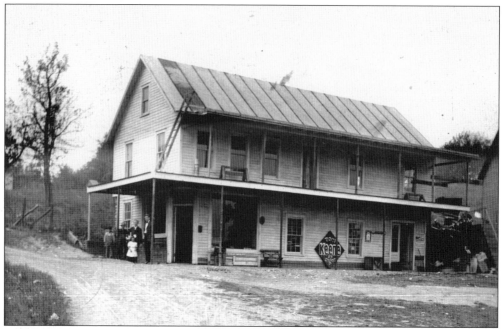

Businesses in small hamlets, such as Colesville, simply tried to met the needs of the customers—farmers and local residents. In 1870, the hamlet had three general stores, four hotels, four mills, a Methodist church, a one-room schoolhouse, a blacksmith shop, a harness shop, and numerous dwellings. However, by 1910, when this photograph was taken, not many of the businesses remained. Seen here is the general store and post office.

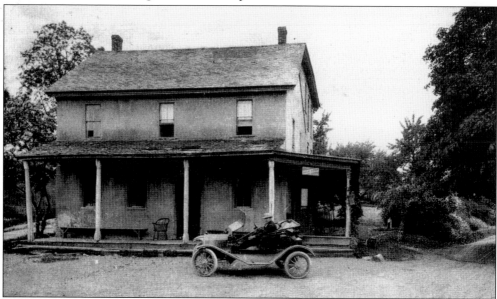

Bevans, now known as Peters Valley, was first settled in the mid-18th century. The village was also known as the Corners and Hensfoot Corners. By 1860, the village had a Dutch Reformed church, a wheelwright shop, a coopers shop, two stores, a hotel, a blacksmith shop and 10 dwellings. The hotel is seen here in 1915, after a large two-story addition had been attached to the rear of the building.

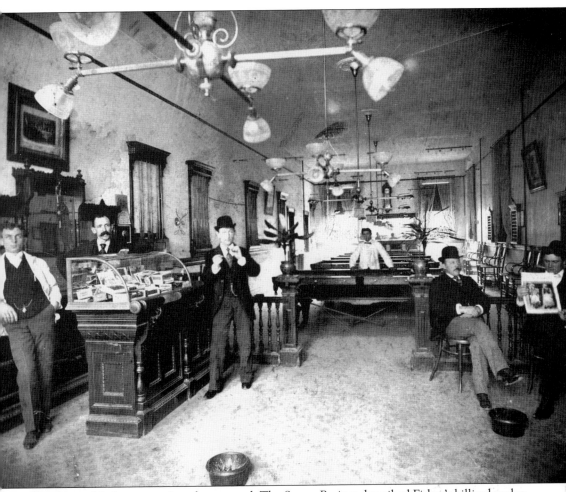

Business and industry continued to expand. The *Sussex Register* described Fisher's billiard parlor this way: "The crowd is 'all right'. . . . Any slight disturbance is promptly quenched and tabooed without further comment. . . . As to the stock: it is all that can be desired in the tobacco and soft drink line and is found invariably fresh. . . . The tonsorial artist . . . is the genuine article. . . . The billiard tables are the most attractive in town and the best constructed. The manager and proprietor, Mr. D. L. Fisher is one of the leading spirits in town and a member of several of our leading fraternal societies."

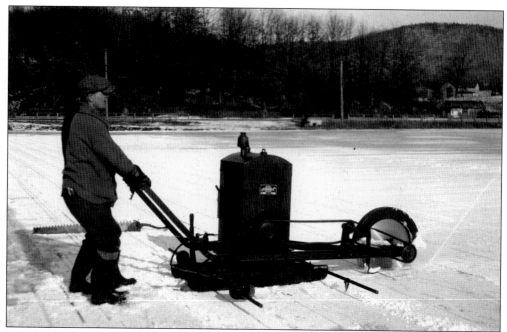

Ice cutting continued into the 20th century. In this view, a gasoline-powered ice-cutting machine, manufactured by the Gifford-Wood Company, has taken the place of horses pulling cutting knives to create the blocks of ice to be stored. This photograph appears courtesy of the Littell Collection, Franklin, New Jersey.

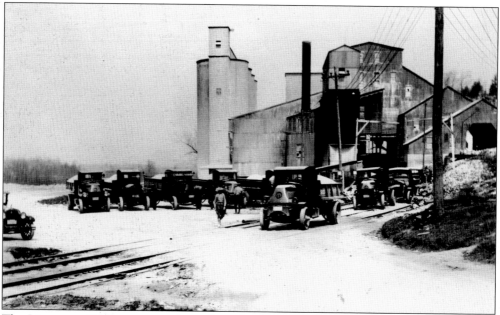

The Limestone Products quarry, located on the Sparta–Lafayette Township border, was first opened by Thomas Edison in the first few years of the 20th century. The scene in this image is from the 1920s, when products from the quarry were shipped locally by trucks with hard rubber tires and long distance by railroad. The truck in the middle has "Sussex County, N.J." lettered on the side of the rear panels.

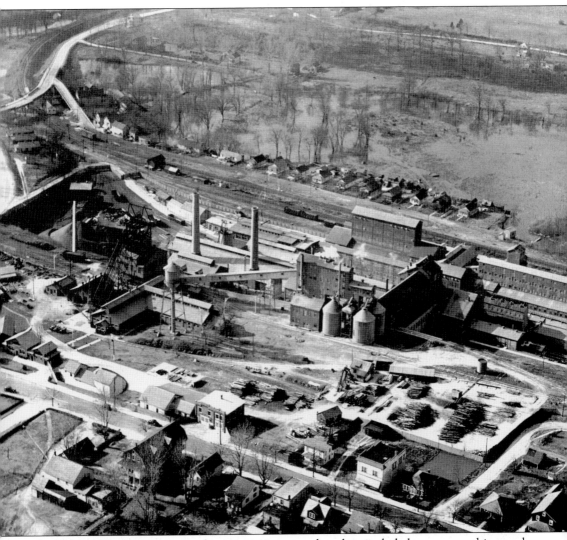

The Palmer Mine was a part of an expansive complex that included an ore crushing and separating plant, as well as an extensive rail yard. This view, taken from a plane east of the complex, shows Main Street running across the bottom of the image. By the time this picture was taken, ore production in Franklin was so extensive that over a dozen sidings had been constructed from the main line of the Lehigh & Hudson River Railway through and around the plant. The headframe of the Palmer Mine can be seen to the left of the pair of smokestacks and water tower. Notice the inclined and enclosed conveyor that carried ore from the top of the shaft up to the ore-drying building. The New York, Susquehanna & Western Railroad had a single line running on the lower level, next to the Lehigh line.

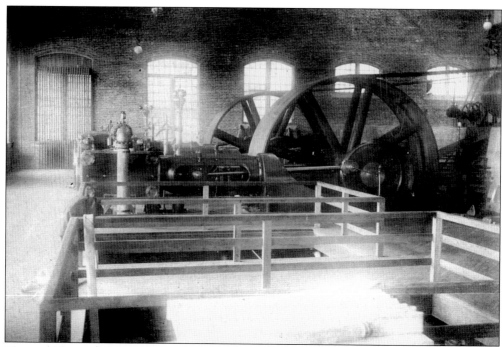

The powerhouse for the mill complex was substantial in size and machinery. Here are two large engines with huge flywheels. The flywheels are connected to electric generators by a series of leather belts. The generators provided the power required to operate the mill complex.

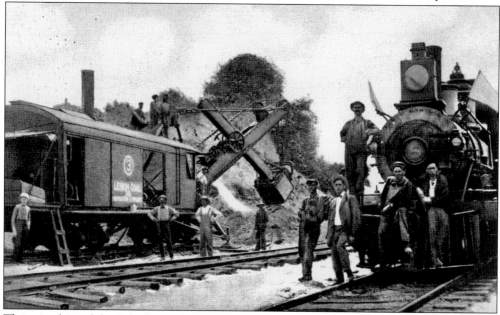

The main line of the Lehigh & New England Railroad came into Sussex County in Wantage, north of Sussex Borough, passing east of the municipality. In this 1915 postcard, a work crew is pictured with a track-mounted steam shovel belonging to the Lehigh Coal and Navigation Company. The crew appears to be widening the right-of-way to permit the addition of another siding. The railroad ceased operation in 1961.

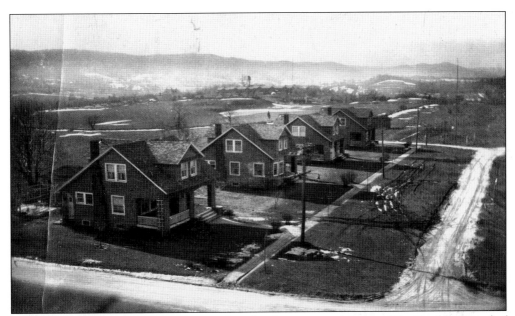

Improvements were also taking place in the school systems at this time. The Franklin Board of Education built a new vocational school, which opened in 1915 and was modeled on a new vocational and industrial school in Gary, Indiana. With housing in Franklin at a premium, the board also built four cottages for teachers, seen here. They were known as "teacherages" and were the only ones in the county.

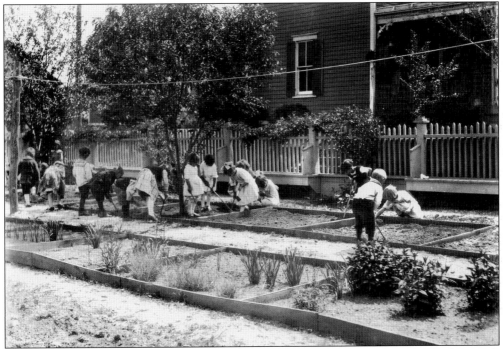

Franklin schools also instituted a program that taught young schoolchildren the fundamentals of gardening. Here, children are working in a series of small square planting areas that have been created for them.

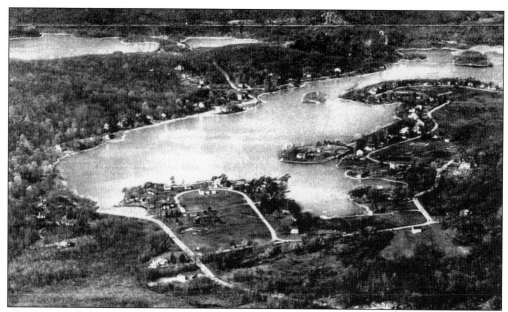

The years following 1900 saw a rapid expansion of seasonal housing growth in the county, particularly around natural and man-made lakes. In Byram, Lake Lackawanna was created in 1910, following the acquisition of three farms totaling just over 800 acres. The lake itself is about 157 acres, with a three-mile-long road around it. This aerial view of the lake shows the development that had taken place by the early 1930s.

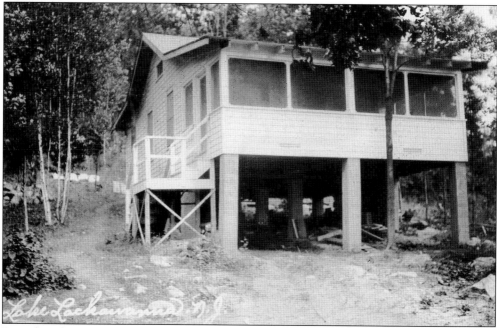

Bungalows began to be built around Lake Lackawanna shortly after the lake was created. This typical summer cabin, set on massive wood piers, included a screened-in porch across the front of the house. The photograph was taken in 1924. In later years, this type of bungalow would be converted for year-round living.

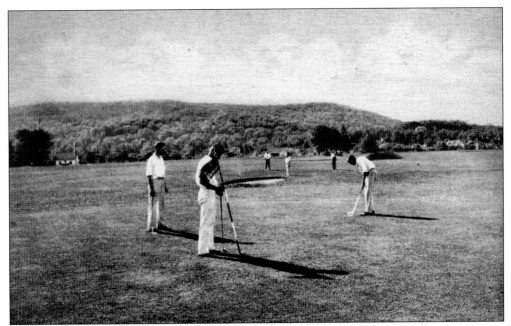

Another amenity created by the Lake Lackawanna Investment Company was the construction of a nine-hole golf course. Unlike the golf courses developed in Sussex County today, with rolling hills, lakes, and large stands of trees, this course was almost entirely flat and very open.

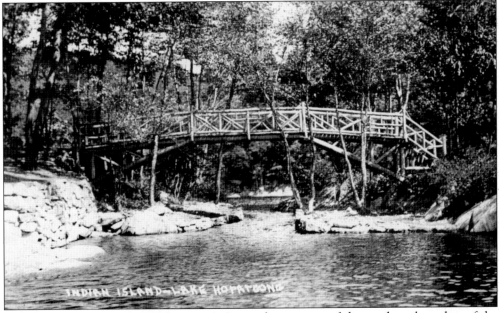

Lake Hopatcong, the largest lake in New Jersey, forms a part of the southern boundary of the county. Development around the lake began in earnest c. 1900, when both large and small hotels and campgrounds began to spring up. Architectural styles ran the gamut from small and rustic to extremely large and extravagant. This simple footbridge, made from locally harvested trees, connects Indian Island to the mainland.

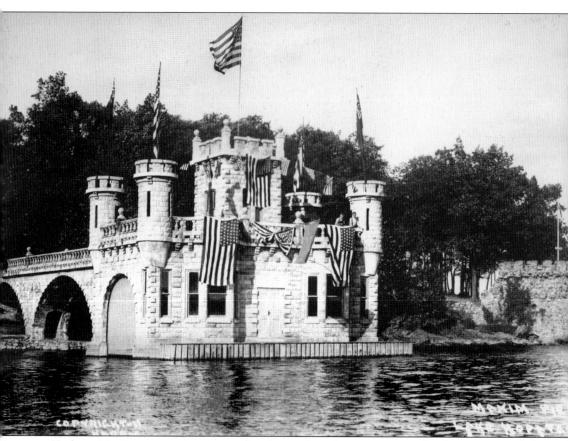

Hudson Maxim was an inventor, scientist, and explosives expert who first came to Lake Hopatcong while working for the American Forcite Powder Company *c*. 1900. Maxim is credited as the inventor of smokeless gunpowder and other propellants for munitions. He acquired 600 acres along the west shore in 1901. Three years later, he built his house, first known as Maximhurst. Seen in this 1907 photograph, the castellated Venetian-style stone boathouse was constructed in 1906. This boathouse, unlike any other built in later years, dominated the west shore for the first half of the century. The boathouse had three floors and a stone fireplace. The American flags displayed on the front of the boathouse have only 45 stars. To the right is a stone structure, with battlements, that served as both an observatory and icehouse.

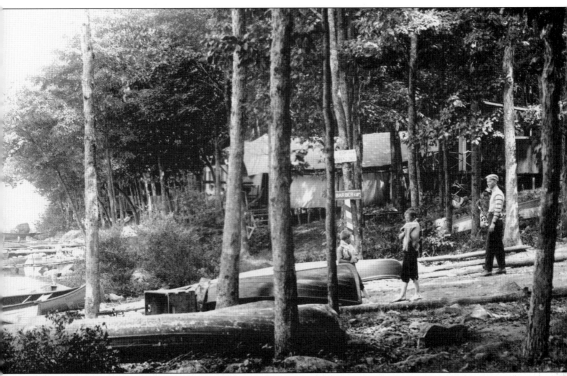

The borough of Hopatcong, established on April 2, 1898, and known as the borough of Brooklyn, was officially renamed Hopatcong Borough by an act of the legislature on March 22, 1901. The lake drew city-dwelling families who stayed in hotels and also "roughed it" in the numerous campsites around the lake. One such camp community was Sperry Springs, situated on the southern shore of Byram Bay. Small sailboats, rowboats, and canoes line the shore. In the distance is a row of tents set on preerected wooden platforms, which made long stays more comfortable. Two young boys, apparently getting ready for a swim, stand beneath a sign pointing to Camp Independence and another showing the location of the barber at Sperry Springs.

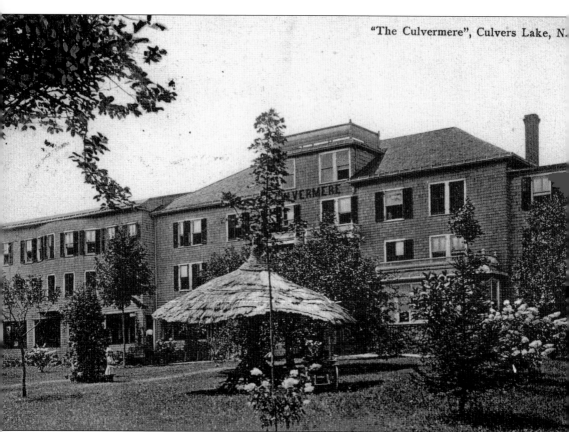

The largest of the hotels that were built around Culver Lake in Frankford Township was the Culvermere. In the mid-1890s, D.H. Fowler purchased land on both sides of what is now Route 206 and built a house for his family there. Realizing the potential of the area as a destination for city dwellers to get relief from the congested urban areas, Fowler built a three-story hotel with a two-story annex. Having worked in the real-estate development market in Brooklyn, Fowler had an extensive number of contacts with people and companies looking for a summer retreat. His hotel had bowling alleys and tennis and croquet courts. In 1901, the number of guests requiring rooms had grown to a point that an addition was built on the hotel. By 1921, the hotel was under new ownership and had added guest cottages and waterfront recreational facilities, with a guest capacity of more than 400.

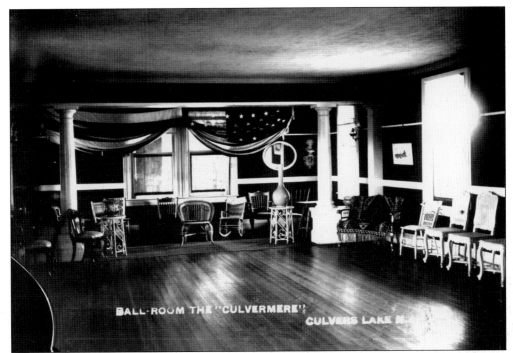

BALL-ROOM THE "CULVERMERE"
CULVERS LAKE N. J.

Small bands would provide the music for guests at the Culvermere to dance by in the ballroom, seen in this 1914 photograph taken from a glass negative. Ballroom dancing was just one of the many activities offered at the hotel, which tried to meet the needs of a wide variety of guests.

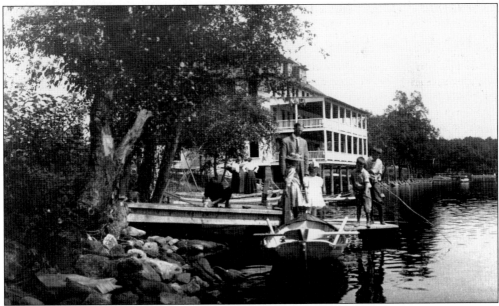

One of the other hotels scattered around Culver Lake was the Mountainside Inn. The hotel was built in 1908 at the foot of Cherry Street on the west side of the lake by Alanson P. Snook. Guests originally arrived here by horse-drawn carriages and later by automobile. Built right along the edge of the lake, the hotel was dismantled in 1939.

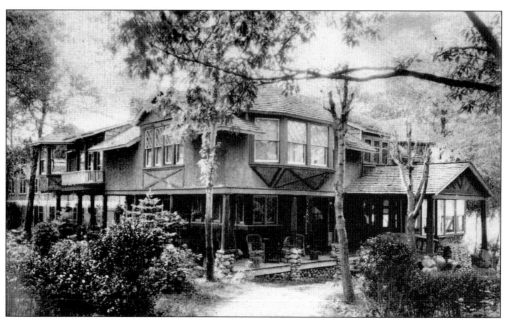

The Crea-Mont Hotel was erected in 1910 by a Mrs. Crane at Hamm's Landing. In 1933, an addition was built, making it a 48-room hotel. The hotel boasted a full-length porch that faced the road. It also had an enclosed promenade that provided a view of both the lake and the mountains. The hotel was later known as the Normanock View and, in 1960, was renamed the Royal Hotel. The hotel burned down in 1964.

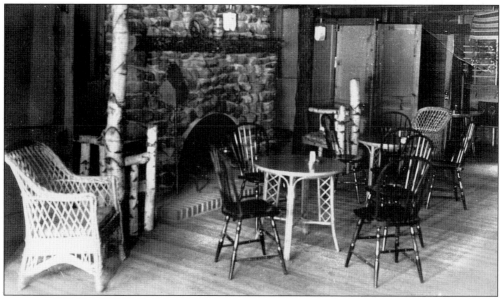

As at many of the smaller hotels around Culver Lake, the accommodations at the Crea-Mont were designed to appear rustic in order to reflect the setting of the lake against the Kittatinny Mountains. Although there were some formal chairs included in the grill room of the hotel, the overall impression is one of a relaxed rustic retreat.

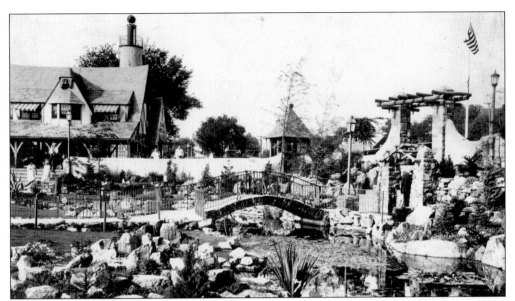

The Arthur D. Crane Company began developing Lake Mohawk in 1926. The company acquired 2,300 acres of land from local farmers and built a dam across the Wallkill River. By 1928, a 900-acre lake had flooded the area once known as Brogden Meadows. The clubhouse and other commercial buildings along the boardwalk were built in 1928 and 1929, on the eve of the Great Depression. This view was taken of the Sunken Gardens in 1931.

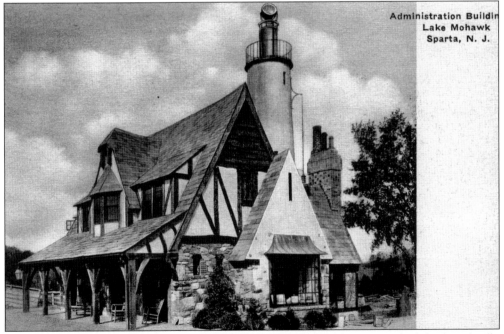

Built in 1928–1929, the administration building is located at the east end of the boardwalk, next to White Dear Plaza. The building exemplifies the early-20th-century revival of the English Norman style of architecture. The structural canopy faces out onto the boardwalk and Lake Mohawk. The searchlight no longer exists.

Some of the earliest houses built around the lake were log buildings with slate roofs. This particular house, identified as "the bull pen" on the back of the postcard, was one of the larger of the log dwellings. This view, taken in 1930, shows the lake just downhill from the cabin.

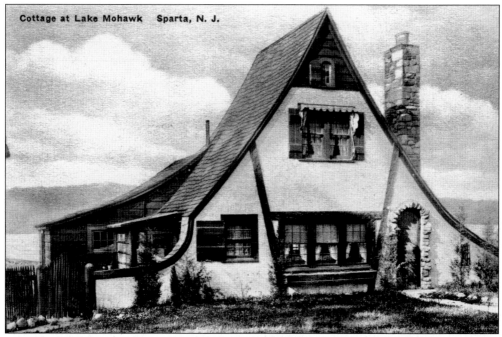

Another style of house built after the lake was created is exemplified by this home on the eastern shore of Lake Mohawk. A whimsical interpretation in the Tudor Revival style, the house offered the homeowner a wonderful view of the lake and hills beyond. The architectural style is loosely based on the domestic English architecture during the reign of monarchs of the House of Tudor (1485–1558).

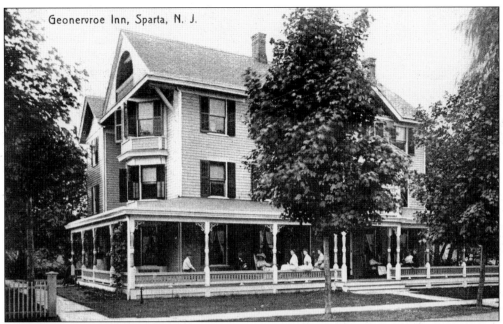

Geonervroe Inn, Sparta, N. J.

With the development of these lake communities came the construction of very large tourist houses in the middle of towns, such as Sparta. This beautiful inn stood on the west side of Main Street. It was established *c.* 1892 by Minerva Roe and had accommodations for 40 guests. The unusual name was derived from the names of the owners, George and Minerva Roe. The site is now buried under the Route 15 overpass.

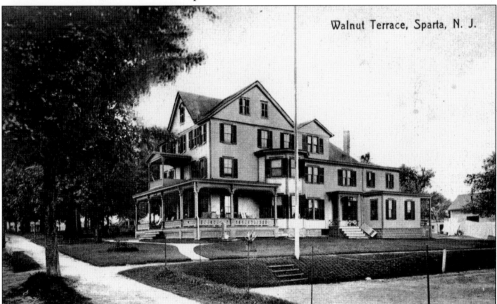

Walnut Terrace, Sparta, N. J.

As the demand of tourists grew, so did the number of hotels built to meet those needs. The Walnut Terrace was one of 10 hotels built in the 1890s and later, with many of them being located in the middle of the village of Sparta. All of them were close to the New York, Susquehanna & Western station, and horse-drawn wagons were sent to pick up and deliver guests who came by rail.

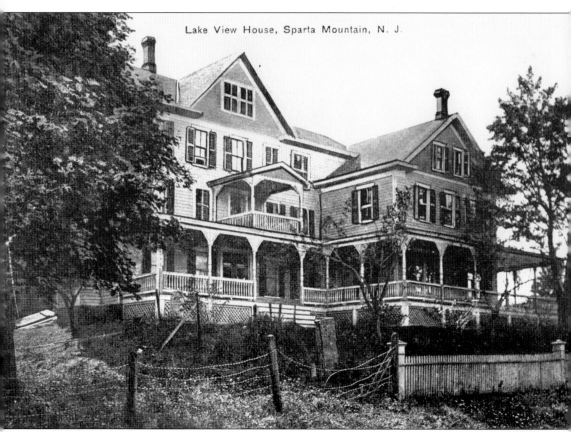

Lake View House, Sparta Mountain, N. J.

In 1906, J.R. Davenport was the proprietor of the Lake View House, located on the Glenn Road opposite the intersection with Morris Lake Road. He charged his 40 guests from $7 to $12 a week, the same as the Central Hotel in downtown Sparta. The house still stands and is now an apartment building. In recent years, the woods have grown back, obscuring the view the hotel once enjoyed of Morris Lake.

Five

THE 150TH ANNIVERSARY

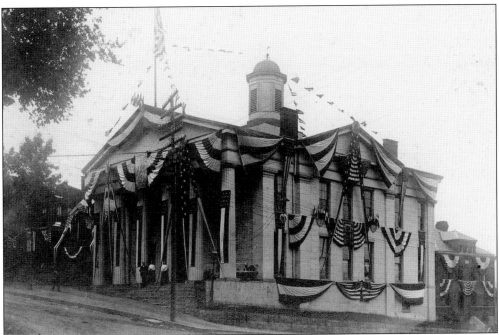

In 1903, the buildings in the middle of Newton were exuberantly decorated with flags and bunting to celebrate the 150th anniversary of the establishment of Sussex County on June 8, 1753. Here we see the county courthouse in all its patriotic glory. There is even a reproduction of the famous painting *The Spirit of '76* hanging above the main entrance to the building. The following nine photographs, taken by George Kintner's studio in Newton, show the center of town ready to celebrate this momentous event. Just as with the 250th anniversary, the Sussex County Board of Chosen Freeholders played a central role in helping orchestrate the celebration events in 1903.

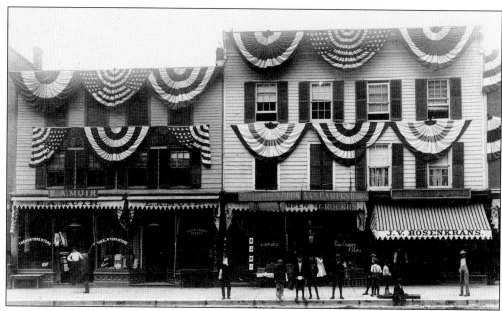

All of these buildings at the west end of Spring Street, close to the county courthouse, were demolished in the early 1970s as part of an urban renewal program. This area was further altered when the intersection of Water, Mill, and Spring Streets was realigned. E.A. Muir's establishment, the New York Store, sold dry goods. The Van Campen Brothers sold groceries, and J.V. Rosenkrans ran a pharmacy.

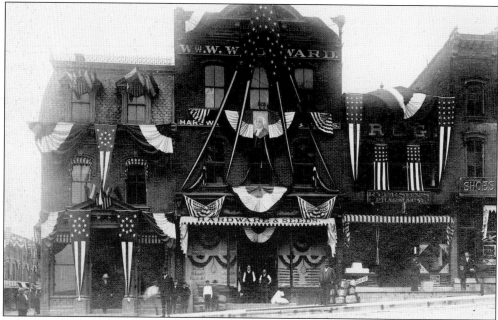

This image provides a good view of the buildings at the intersection of Main and Spring Streets, including the Sussex Bank, the W.W. Woodward hardware store, and the Ryerson pharmacy. These are all excellent examples of mid- to late-19th-century commercial architecture. The bank building was erected in 1871. Woodward's was extensively remodeled after a fire in 1873, and Ryerson's was built in 1881.

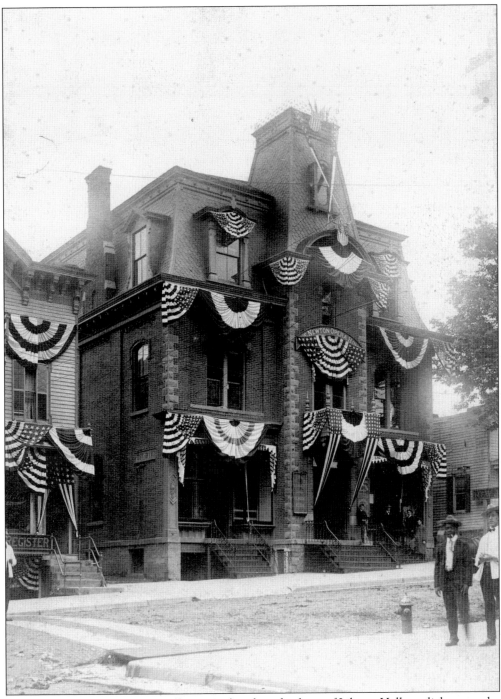

Not even the massive amount of bunting placed on the front of Library Hall can lighten up the somber facade. Erected in 1871, this building housed the Dennis Library, the post office, the Newton Opera House, and several other businesses. Designed in the Second Empire style of architecture, the building was demolished to make way for the current architecturally nondescript post office structure.

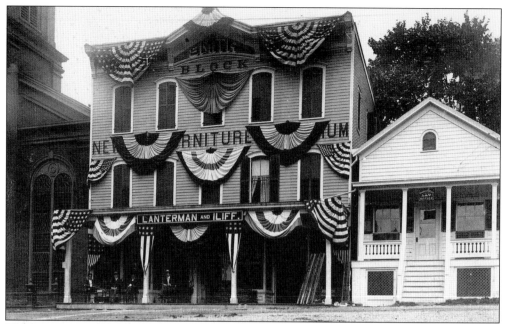

The Lanterman and Iliff furniture shop and Thomas M. Kay's law office were the last surviving wood-frame buildings on Park Place. These structures, which were built shortly after the Civil War, were demolished in 1929 to make way for the new Sussex County Hall of Records, which was officially opened in July 1930.

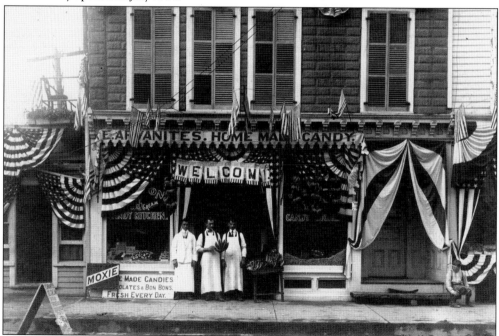

E. Arvanties or one of his employees proudly displays a bunch of bananas at the candy shop, located at 124 Spring Street. The small one-story building to the left of the store is gone. In place of the building is a driveway that leads up to the parking lot in back of the Fire Museum and Spring House.

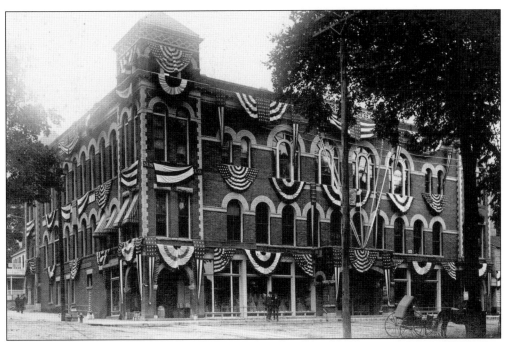

At the time of the county's sesquicentennial, the Park Block Building was the premier business structure in Newton. W.D. Ackersons's department store was located on the first floor. Newton Business College and a number of law offices were on the second floor. The top floor was home to the English and Classical School, operated by Helen Pierce and Lillian Rosenkrans, and the offices of the Sussex Telephone Company.

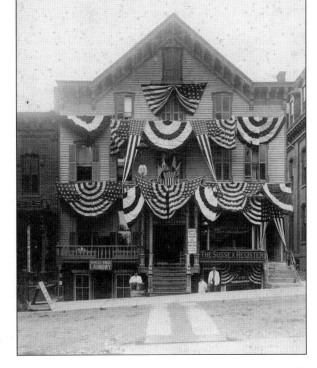

This two-and-a-half-story frame building stood on the site of the current post office driveway. Here, the *Sussex Register*, one of Newton's two weekly newspapers, had its editorial offices and pressroom. It also housed a ladies' dining room and ice-cream parlor (owned by M.S. Devore), the office of the Newton Gas and Electric Company, and Charles Wing's laundry.

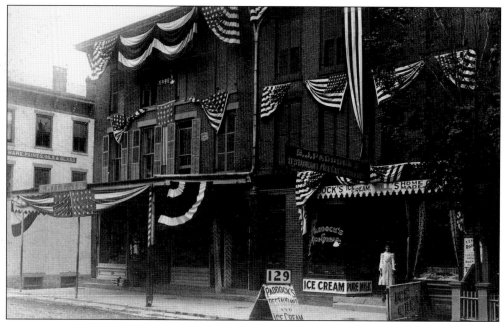

Sam Hill's grocery store, located at the corner of Spring and Moran Streets, was the last store on Spring Street to have a structural cover over the sidewalk. In the mid-19th century, virtually all of the stores along Spring Street had such structures that provided protection to pedestrians from both the sun and rain. Retractable canvas awnings eventually replaced these structures.

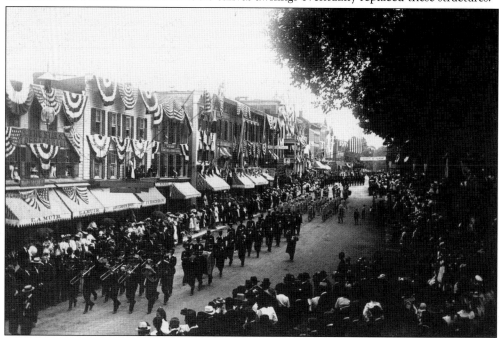

No celebration would be complete without a parade followed by speeches, and the 150th-anniversary celebration was no exception. In this view, a band is coming down Spring Street, followed by members of a local fire company. Crowds fill the square and the street in front of the county courthouse.

Six

MODERN SUSSEX COUNTY

In the period just after World War II, Sussex County still had more cows than people. This began to change after 1960, when families began to move out of the cities and older suburbs to western Morris County and Sussex County. Many of the things county residents had taken for granted over the decades began to need replacement due to increased heavy use. One such thing was the old iron bridges that dotted the countryside. Like this Pratt-style iron bridge that passed over the Paulinskill near the Main County Library, these bridges erected prior to 1900 began to fail structurally, forcing their replacement.

The lake communities that once served as summer retreats for families began to have the housing converted for year-round occupation. New homes were being built on the vacant lots, increasing the population around the lakes. Here, crowds gather on the boardwalk at Lake Mohawk to watch two powerboats circle around a small sailboat while a rowboat tries to land at the bottom of the boardwalk.

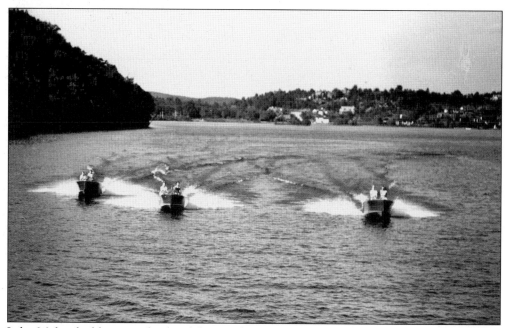

Lake Mohawk, like several other lakes in the county, saw an increased use of the lake for powerboating. Three Chris-Craft are seen here going through a coordinated maneuver.

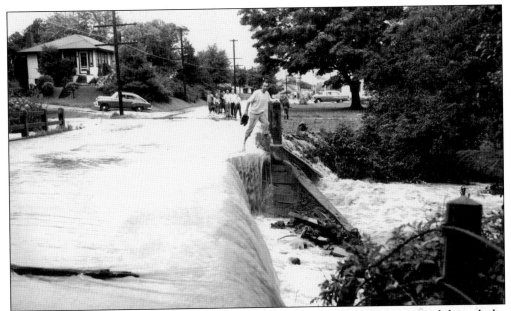

Disaster struck Sussex County on August 19, 1955, when part of a hurricane passed through the county and caused millions of dollars in damage. Hardest hit by the storm was Branchville. Here, Newton Avenue, one of the main streets in town, has been partially washed away after the Branchville Dam was breached. The dam held back Electric Pond, a large body of water in the borough.

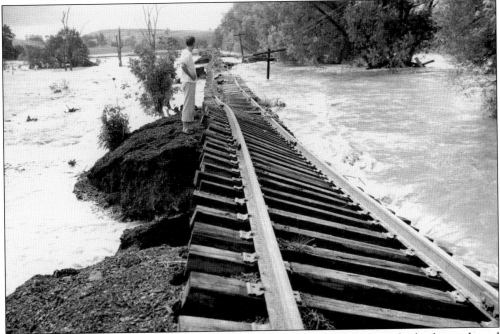

Once the Branchville Dam failed, the torrents of water cascaded through the borough and washed out not only roads but railroads and their embankments as well. In this image, the line of the Delaware, Lackawanna & Western entering Branchville Borough has been totally undermined, requiring a massive effort to restore service in the weeks after the storm.

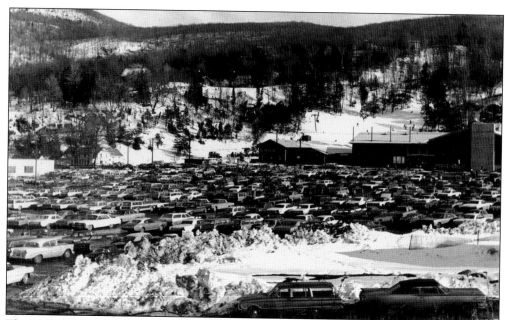

The Great Gorge Ski Area, which began full operations in 1965, was the first ski facility in Vernon Township. The ski slopes of Great Gorge have a drop of nearly 1,000 feet down Hamburg Mountain. Otto Schneibs designed the slopes and also designed several famous ski resort trails in the United States and Europe. In this early-1970s photograph, the parking lot at Great Gorge is full, with the slopes packed with skiers.

Vernon Township is the site of the largest ski facilities in New Jersey. On a cold day or evening, with sufficient snow on the ground, thousands of skiers will come to Hamburg Mountain to test their individual skills on the slopes.

The road network that was adequate for carriages, automobiles, and a relatively small population did not always measure up to the demands of an increasing population. In this 1979 view, the Ross' Corner–Sussex Road is being realigned, with a new crossing over the Papakating Creek. The county engineering department continues to develop plans to systematically upgrade the entire county road network over a number of years.

In the 1980s, the town of Newton saw major road reconstruction and realignment take place in the center of town. The realignment of Spring, Water, and Mill Streets was intended to help increase the flow of traffic through the middle of the county seat. Water Street (Route 206), which extends to the lower left of the image, was widened to three lanes after the completion of the realignment work.

With the completion of Route 80 west to Sussex County in the early 1970s, access to the area was vastly improved. No longer did drivers have to take time-consuming, winding narrow roads out to the rural northwest county. The opening of Route 80, seen here passing just south of Waterloo Village in Byram, presaged the rapid growth that the county was to experience in the 1970s through the end of the century.

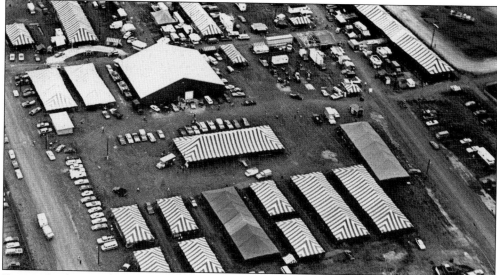

Yet another barometer of the changing times in Sussex County was the relocation of the Sussex County Fair from the borough of Branchville to the new county fairgrounds on Plains Road in Frankford Township. Seen in this aerial photograph taken in 1977, the middle of the new fair complex includes a number of large tents to house the various exhibits. Twenty-five years later, permanent buildings have replaced most of the tents.

Seven
SUSSEX COUNTY LOST

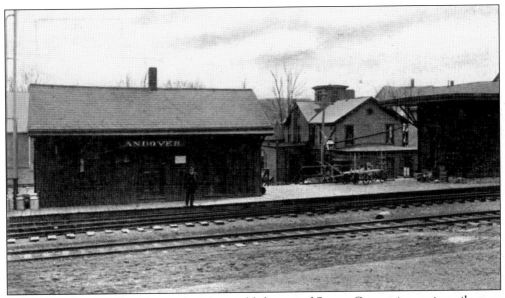

Celebrating the 250th anniversary of the establishment of Sussex County is a major milestone for the county community. In the last 30 years, the county population has almost doubled. Houses, schools, golf courses, and commercial complexes continue to rise up from the soil of the county's rolling hills. However, with the modernization of the county comes the realization that we have lost a great deal of our physical heritage—that which ties us to our past. The Andover station on the Delaware, Lackawanna & Western is seen in this 1915 image. Like the other stations on the line, it no longer exists.

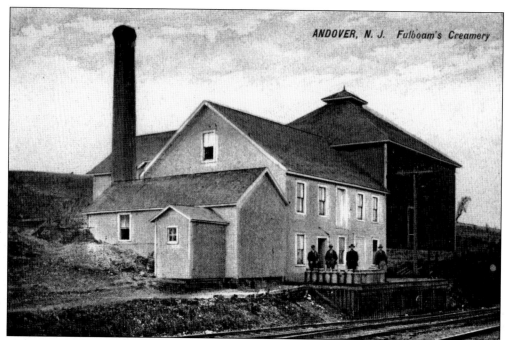

The creamery in Andover Borough stood just north of the railroad station, on the west side of the tracks of the Delaware, Lackawanna & Western. It was built in 1861 by Albert Puder, and the building was later moved to this site along the railroad and then expanded. It continued to operate under a succession of owners, including George Fulboam, until the late 1940s, when it was torn down.

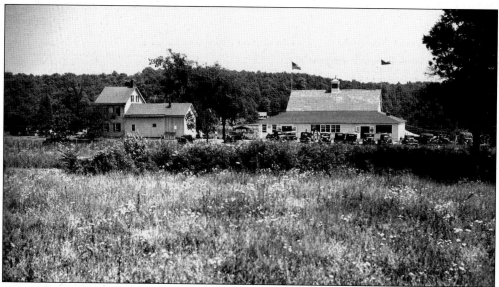

Camp Nordland, a German-American Bund camp located in Andover Township, opened c. 1937, with about 400 children registered that summer. A key part of the membership and indoctrination program was the creation of a chain of recreational and youth camps. By the summer of 1941, Camp Nordland was closed, with Sheriff Denton Quick seizing the camp on the orders of the attorney general. The buildings have subsequently been reused.

110

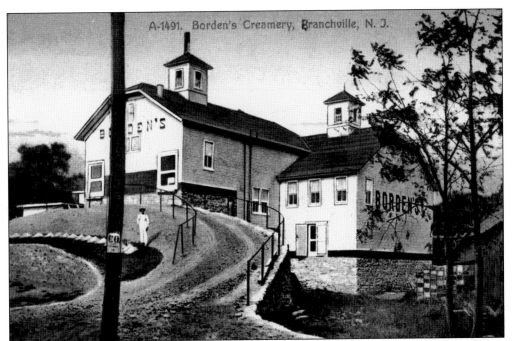

The Borden's creamery in Branchville served a large number of local farmers, helping them to process their milk and then ship it out on the Delaware, Lackawanna & Western. One of the larger of Borden's creameries in the county, it was later operated by the Sussex Milk and Cream Company. The plant ceased operation on September 1, 1962, after the main boiler had exploded. It was subsequently torn down.

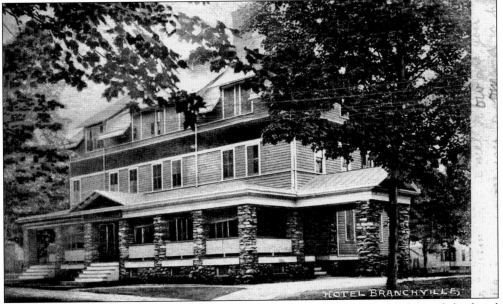

Like many other towns with a railroad station, Branchville had a large demand for hotel accommodations. The Branchville Hotel was the largest of several hotels in the borough and had a reputation of "satisfied guests." The hotel was demolished to make way for the present post office building.

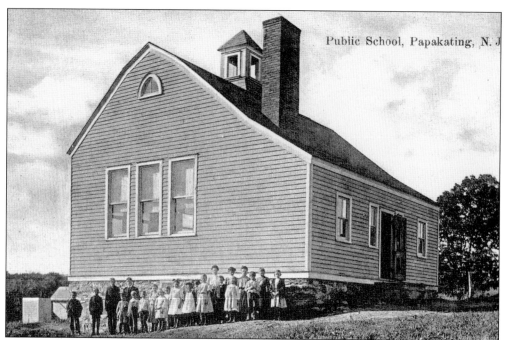

The Papakating School, located in the hamlet of Pellettown in Frankford Township, was one of nine school districts in the township as of 1868. In this 1910 postcard image, 18 students of varying ages stand outside of their school with their teacher and the township school principal. The majority of what was once a very large number of one-room schoolhouses have disappeared from the landscape of the county.

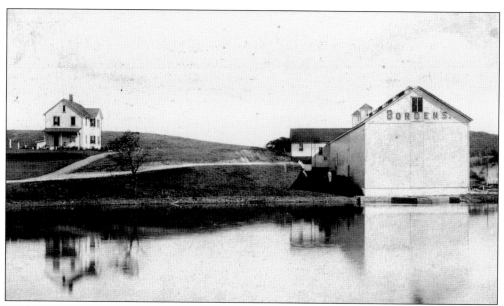

Borden's operated a large creamery at Pellettown, with the Lehigh & New England Railroad passing next to the building. Opened in April 1897, the creamery served local dairymen for 38 years, until it closed June 30, 1935. The house in the distance still stands, but the pond is drained and only the foundation walls of the creamery survive.

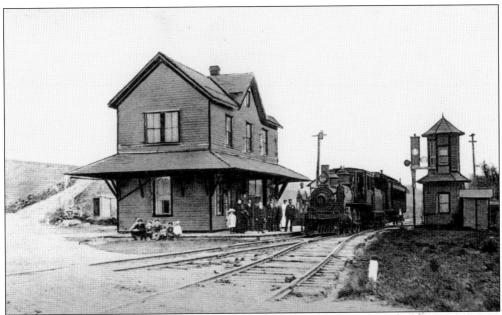

The Delaware, Lackawanna & Western and the Lehigh & New England Railroads crossed their lines at Augusta in Frankford Township. They shared the cost of building the 16- by 38-foot two-story wooden station (about $800). Like almost all of the railroad stations in the county, this station and the octagonal control tower were leveled by the 1940s. The iron horse was being replaced by the truck and family car.

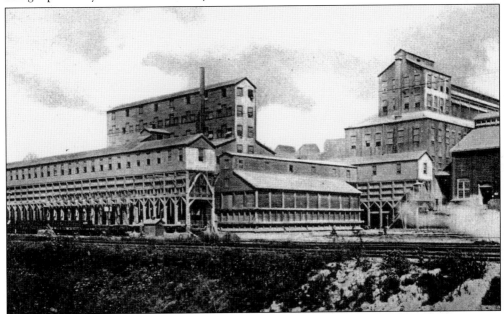

Looking east from the massive railroad yards that served the mine, this view shows the separator works at the Palmer Mine and Mill complex in Franklin. Ore was hoisted up from the mine shafts and then run through a series of crushers and separators before being loaded into rail cars and taken to the smelter in Pennsylvania. This entire complex, which employed hundreds of men, was demolished more than 30 years ago.

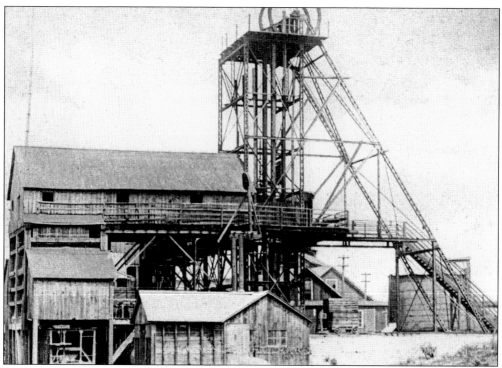

Miners in Franklin began sinking the Parker Shaft in 1891 and reached a depth of 207 feet by January 1892. After pumping out the mine (which had become completely flooded), workers continued the digging until 1894, when a depth of 975 feet was attained. The mine, purchased by the New Jersey Zinc Company in 1897, was not very productive. It operated for only 16 years. All of the equipment and buildings were removed more than 60 years ago.

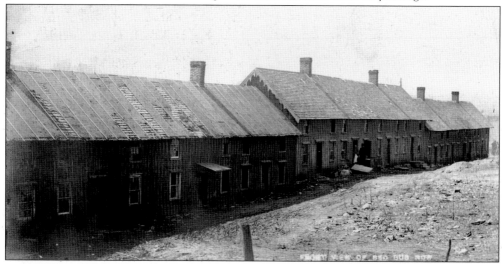

Bed Bug Row was tightly sandwiched between Franklin Pond and Franklin Avenue. Built prior to the Civil War, this example of crude early miners' housing provided for some of the fundamental needs of the immigrant laborers and miners. Outhouses were located between the row of houses and the pond. The row was in continuous use until just prior to 1910, when the buildings were torn down.

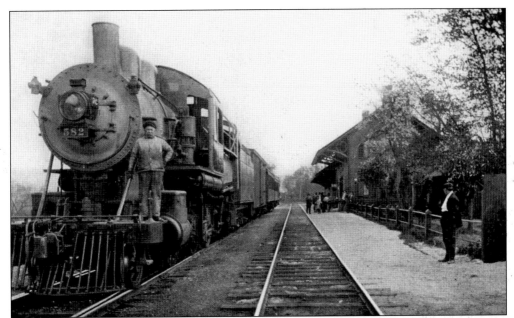

A Delaware, Lackawanna & Western (DL & W) engine stands in the Franklin station. This station was the official end of the DL & W in the eastern part of the county, and it was shared with the New York, Susquehanna & Western (NYS & W). The DL & W built the station, but the NYS & W paid for half of the cost. The station, which accommodated both passengers and freight, was demolished like many others along the DL & W.

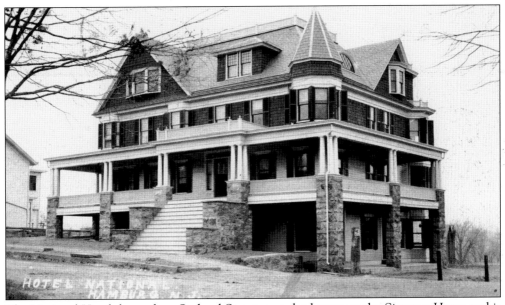

The National Hotel, located on Orchard Street, was also known as the Simpson House and is the second hotel to have stood on this site, the first having burned in 1903. The hotel seen here was built in 1906 and was designed partially in the Shingle style of architecture by Jonathan Dymock. The hotel was torn down around the time of World War II. In 1957, the site was cleared and a post office was built there.

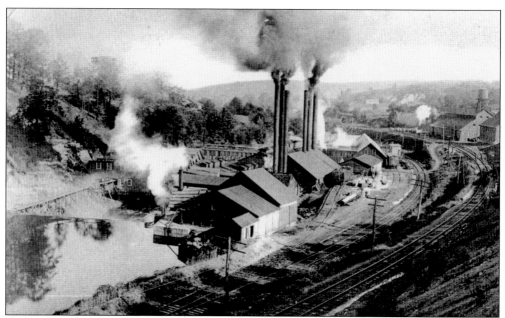

The New York, Susquehanna & Western ran north from Franklin on the east side of the Wallkill River to Hamburg. The Hamburg Paper Mill was built in 1891 by Samuel and Edward Sparks. By 1900, the business was renamed the Union Waxed and Parchment Paper Company. The plant, which was served by the New York, Susquehanna & Western, was totally destroyed by fire on January 7, 1935.

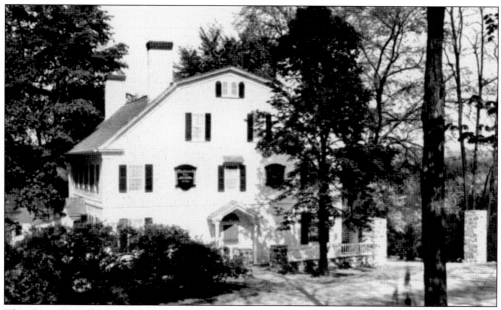

The Gov. Daniel Haines house was built c. 1800 by Joseph Sharp in Hamburg. Haines, who served as governor of New Jersey in 1843 and from 1847 to 1852, acquired the house in 1824 and lived there until his death on January 26, 1877. The house was converted into the Wheatsworth Inn during the last half of the 20th century, as pictured above. The building was lost to a fire in April 1985.

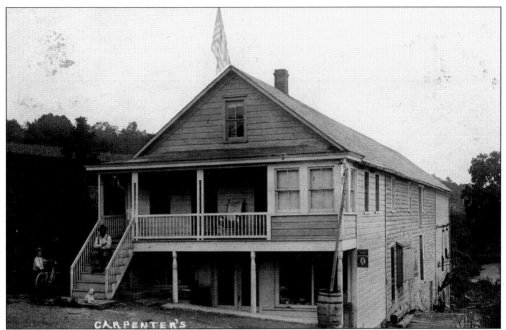

Carpenter's Store was located in Baleville, to the east of the twin bridges in Hampton Township. Located next to the New York, Susquehanna & Western Railroad, the store was the center of this small hamlet for shipping goods in and out by rail. On the opposite side of the street, where photographer Alva Jackson Bloom stood to take this picture, was the Baleville Creamery. Neither building survives.

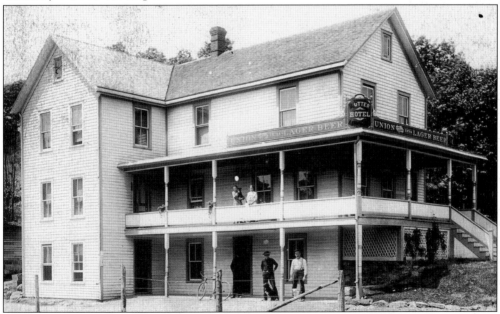

One of several hotels in the village of Stockholm was operated by Hiram Utter, seen in this 1904 photograph. The hotel stood on the northeast side of the New York, Susquehanna & Western station and was thought to have been built by Thomas Booth for the employees of the knife factory he operated. The hotel was destroyed by fire on May 6, 1905.

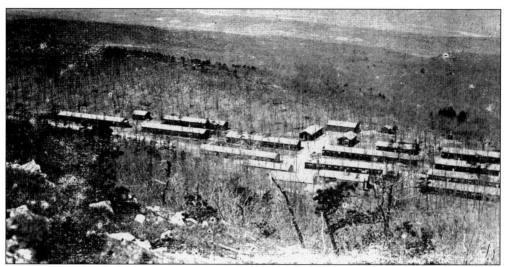

In 1933, during the height of the Great Depression, Pres. Franklin Roosevelt established the Civilian Conservation Corps (CCC) "to be used in simple work, not interfering with normal employment, and confining itself to forestry, the prevention of soil erosion, flood control and similar project." Civilian Conservation Corps camps, such as High Point State Park, were established throughout the country. The CCC program ended with the outbreak of World War II.

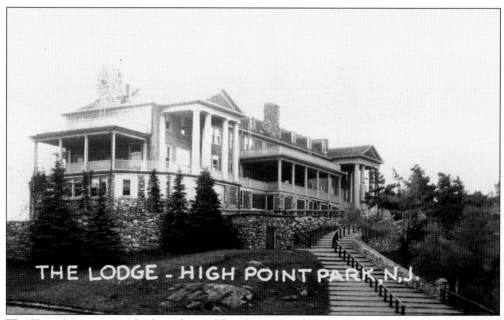

The Kuser Mansion was built in the middle of a 10,000-acre tract by Col. Anthony Kuser and his wife in the early part of the 20th century. The Kusers donated the mansion and the land to New Jersey, creating the first state park. The state used the mansion for different purposes over the decades but allowed this grand building to fall into disrepair. The state demolished the mansion on October 11, 1995.

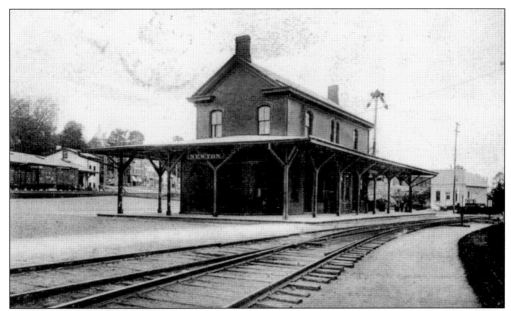

At the end of Spring Street used to stand the Lackawanna Railroad passenger station, constructed in 1873. The east end of the station is seen in this view, which looks back toward Spring Street and the center of Newton. On the left side is the freight station, which still stands but in a modified form. Until July 1966, commuters could still travel by train from Newton to Hoboken and towns in between.

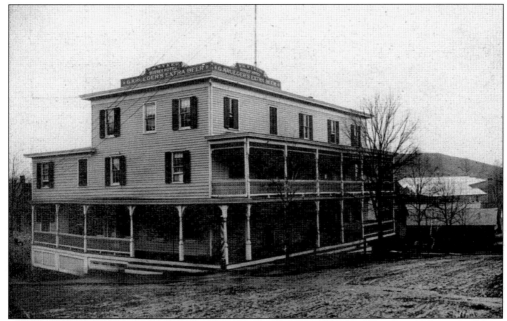

At the old intersection of Mill and Water Streets once stood the Sussex Hotel. Water Street is on the right and is overlooked by the two-story porch on the hotel. The oldest portion of the hotel dated to 1818, when it was referred to as the Phillips Hotel. At the time of the Civil War, it was known as the Durling House. In its final years, it was called the Burns Hotel. It was demolished in 1964.

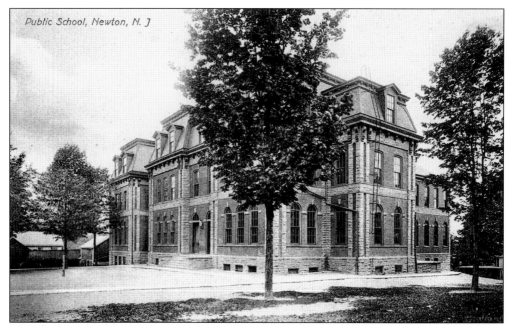

Public School, Newton, N. J.

In 1869–1870, this beautiful mansard-style school was built on the east end of Halsted Street in Newton. It served the town's schoolchildren until the 1950s, supplemented in 1919 by a new high school built next to it, which is still used as an elementary school. Structural problems led to the older school's abandonment in the mid-1950s. The building was demolished in 1962.

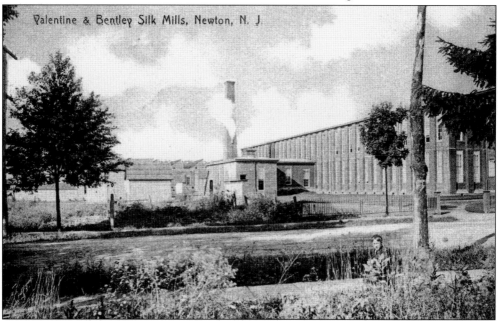

Valentine & Bentley Silk Mills, Newton, N. J.

Erected as the Sterling Silk Works in 1895, this factory was located on Sparta Avenue across from the Merriam shoe factory in Newton. This was just one of many "satellite" silk mills that were established by Paterson manufacturers trying to escape the trade union movement that was gaining wide support among workers in the urban areas. The mill was later home to a plastics firm and was razed in 1994.

In 1861, Newton's Methodists built this attractive brick church on the south side of Park Place, facing the green in Newton. Due to a lack of available parking, the congregation erected a new church edifice at the end of Ryerson Avenue in 1963. The old church was demolished to provide parking for the Newton Trust Company.

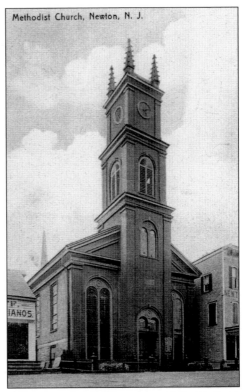

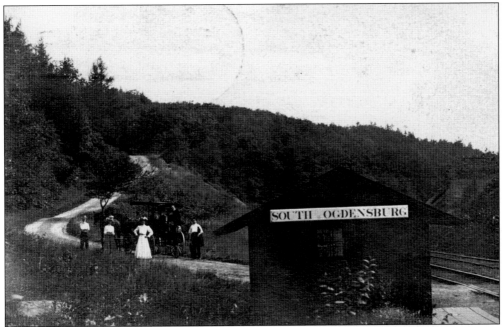

This is an extremely rare view of the South Ogdensburg station, which was located at the intersection of the New York, Susquehanna & Western tracks and Edison Road, exactly halfway between the stations at Beaver Lake and Sparta. This small wood "shed" station vanished by the 1950s.

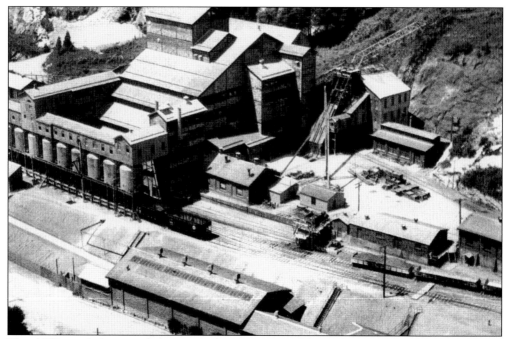

This 1950 aerial photograph depicts the lower portion of the Sterling Hill Mine in Ogdensburg. The ore was crushed in the largest building, known as the processing house. Once the ore was completely processed, it was moved by conveyors to the large cylindrical bins on the left and was then loaded into railroad ore cars. With the exception of a few buildings in the foreground, none of the buildings still stand.

This 1910 postcard, showing the Layton Hotel and an iron Pratt half-hip truss bridge in Sandyston, reflects the quiet serenity of the small village. Although the hotel still stands, the iron-truss bridge, like the vast majority of similar structures throughout the Sussex County, was demolished and replaced with a more modern bridge.

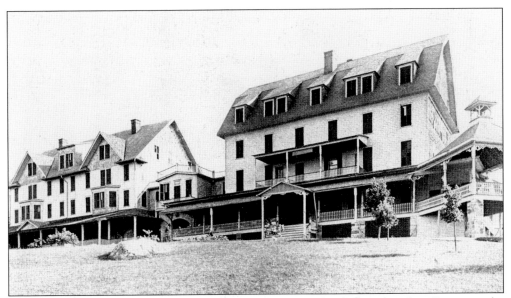

The Everett House was one of the largest hotels or boardinghouses found in Sparta at the beginning of the 20th century. It was just one of 25 such establishments that catered to seasonal visitors, who came by train to the mountains for the pure air, quietness, and good water. In 1907, the hotel keeper was able to fill both of the large structures. The onset of World War II, combined with a drop in visitors, caused a decline in business, and the complex was torn down in 1942.

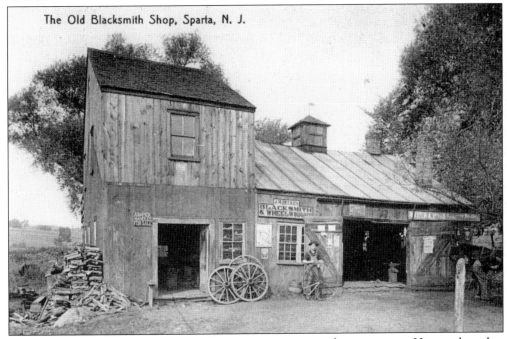

The blacksmith and wheelwright were once important parts of a community. Here, a shop that houses both trades stood on Woodport Road, just north of the intersection of Woodport and Mohawk Roads. Shown in the 1860 Hopkins map of the county, the shop was thriving in 1908, when this photograph was taken. This building was demolished more than 50 years ago.

The Musconetcong Iron Works complex was located on the site of the Compac Paper Company in Stanhope. This 1908 postcard view shows a part of the tall furnace in the center, with round metal "stoves" located in back of the building with a cupola, on the right. The stoves preheated the air, which was forced into the fire within the furnace. All of these structures are now gone.

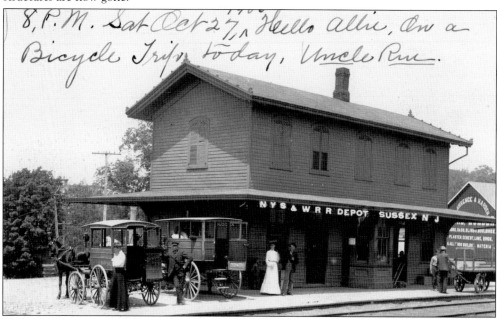

The borough of Sussex, originally known as Deckertown, was the focal point in northern Sussex County for commerce, manufacturing, and transportation in the late 19th and early 20th centuries. This 1906 photograph shows the New York, Susquehanna & Western's two-story passenger station. The two wagons are waiting for passengers to arrive and will take them to local hotels. With the demise of the rail line, the station was removed.

124

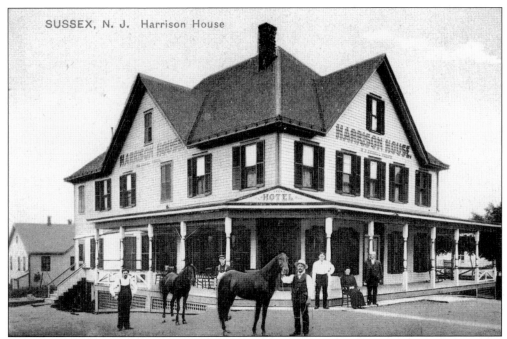

Located directly behind the railroad station was the Harrison House, one of the larger hotels in Sussex Borough. This 1910 postcard shows the hotel proprietor with some of his staff in the background on what appears to be a warm summer afternoon. This hotel, along with a few others in the borough, served the needs of the traveling public for decades. Although this hotel no longer stands, two others do remain.

The imposing two-story brick Sussex High School was erected in 1903 on a hill overlooking the center of the borough. The plans were drawn by C.J. Baxter, the school superintendent of New Jersey. This building replaced a two-story, five-room schoolhouse that was built around the time of the Civil War. This school was razed to make way for additional municipal parking.

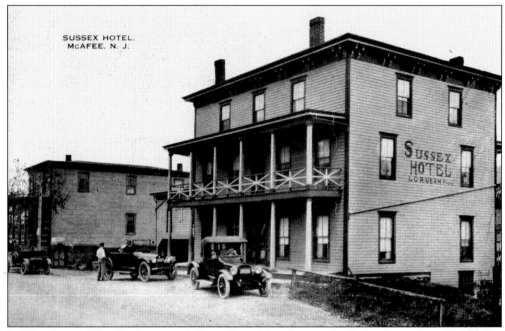

In the early 1890s, this wayside inn was known as Simpson's Hotel, located in McAfee in Vernon Township. Shown in a 1920s postcard, the hotel was then owned by L.C. Ruban. In later years, it was called Hovencamp's Hotel. A major fire and reconstruction in the 1930s dramatically altered the appearance of the building, which is now known as the George Inn.

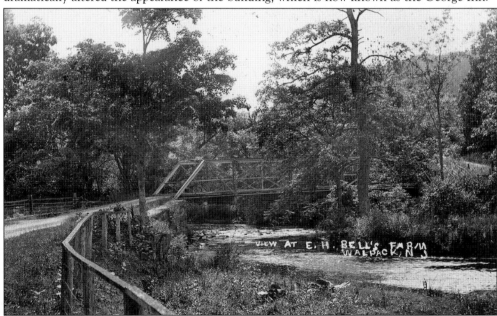

A modified iron Pratt half-hip truss bridge, set on well-laid stone abutments, is seen in this 1906 photograph of a narrow dirt road crossing over the Flat Brook on the Emmet H. Bell farm in Walpack. This once popular style of bridge (used to span relatively narrow streams or rivers) could be found throughout the county. Today, there are very few examples remaining of this testament to simple but functional engineering.

Buttermilk Falls, in Walpack Township, is not only a beautiful natural wonder to watch, but it also provided a source of power to operate a mill located at the foot of the falls. Water would be diverted from the main flow cascading down the face of the cliff into a wooden trough. This directed the water to an overshot wheel that was the sole source of power for the mill.

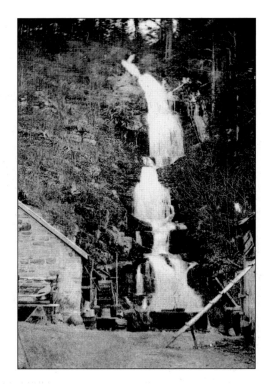

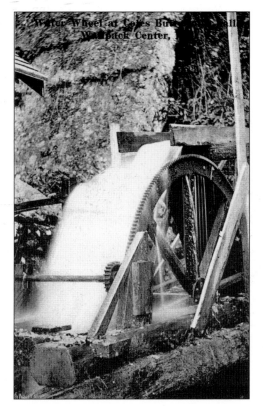

The overshot waterwheel that powered the adjacent mill at Buttermilk Falls is seen in detail in this 1906 image. This is probably a replacement wheel, as the original one would most likely have been made entirely of wood. This quaint stone mill and waterwheel, once tucked into a little-visited area of the county, are gone, leaving only what nature had created there originally—Buttermilk Falls.

Lost is the gentle innocence and serenity that once was Sussex County.